INTRODUCING

Picasso

Andrew Brighton and Andrzej Klimowski

Edited by Richard Appignanesi

 Totem Bo

First published in the United States in 1996 by Totem Books
Inquires to PO Box 223, Canal Street Station
New York, NY 10013

Distributed to the trade in the United States
by National Book Network Inc.,
4720 Boston Way, Lanham, Maryland 20706

Originating editor: Richard Appignanesi

ISBN 1 874166 29 3

Library of Congress Catalog Card Number: 95-62413

The Picasso Myth

Picasso's qualifications for the title of "Great Artist" were many. He had deep black eyes. He came from what was a strange and exotic part of Europe. He had strong features and a fine-looking head. He was an infant prodigy. He lived the bohemian life. He had affairs with many women. His work was abused by reactionaries and sold for very high prices.

The idea of the "Great Artist" demands mindless admiration from us; it suggests an authoritative consensus. The cliché is hard to avoid in a book about Picasso, commonly accepted as *the* great artist of the 20th century. He has served as an emblem of modern artistic genius, rather as Einstein has served as the scientific equivalent. Their names figure in jokes as well as history books.

The Infant Prodigy

The cliché idea of the "Great Artist" requires evidence that God or nature endowed him or her with special abilities, the capacity to perform prodigious feats without education or training. Doña María, Picasso's mother, claimed that her son could draw before he could talk.

Picasso massaged the tales of his boyhood to evoke a picture of a school-rejecting, drawing- and painting-obsessed infant. However, the few existing drawings and paintings made in his first ten years do not show extraordinary ability, and the records of his school career are less colourful than the myth suggests.

The myth of Picasso as infant prodigy is usually presented with the story of his artist father, Don José, asking him to work on one of his own paintings and on seeing the results handing his palette over to Picasso.

Picasso was not yet fifteen when this supposed event took place, not an infant. At that time, his father was in his late fifties, his sight was deteriorating and his career was at a low ebb.

While continuing at secondary school, Picasso had been going to classes at the local academy since he was ten. It seems likely that Don José asked Picasso to paint the fine detail on the legs of some pigeons, and, after having undergone four years of art school classes, Pablo made a very good job of it. What we do know for certain is that Don José did not give up painting.

"Kill Your Father"

Those who perpetuate the myth of the "Great Artist" prefer to neglect Picasso's seven years of academic training, all but two of those years, the years in Madrid, in institutions where his father taught. He certainly developed immense facility, but it was a conventionally trained facility.

That Picasso took what may have been a statement of parental encouragement and in middle age needed to tell it to his secretary and biographical myth-monger, Jaime Sabartés, as a story that humiliated the memory of his father is itself significant. He was to tell a fellow student in 1898 that . . .

It was at that time that he gave up Ruiz, his father's name, in favour of his mother's, Picasso. However, it also indicates that Picasso's notion of being an artist was informed by the myth of artist as special being. As an explanatory tool, it has little value, but, as a chosen role for an artist of great ability, it can be a productive, as well as cruel master.

Childhood and Youth

Picasso was born in 1881 in Malaga in Andalusia, the most southern region of Spain. Malaga was a culturally provincial Mediterranean seaport and his family were downwardly mobile. José Ruiz Blasco (d.1913), Picasso's father, was from a well-established bourgeois family. One of his brothers was a diplomat, another a doctor and the third a priest of some rank. The irreligious Picasso was named Pablo after the priest who died two years before he was born. Don José trained as a painter at the undistinguished local academy, had little success as an artist and eventually returned to the academy as a teacher. He specialized in painting pigeons. The family survived on Don José's small academic salary and the support of his more successful brothers.

María Picasso y Lopez was Don José's cousin. They married in 1880. She was twenty-five years old, he was forty-two. Her family's wealth had been in vineyards, but they were devastated by the grape phylloxera in 1878. Pablo was the first of their three children.

John Richardson (1924–), who has published the first volume of what is to be the most detailed biography of Picasso in English, has argued that the women in Picasso's life are central to understanding his art. When the women in his life changed, so did his work, claims Richardson. However, all he can tell us of Doña María, the first woman in Picasso's life, as a person is that she was "vivacious, good-humoured and incorrigibly optimistic". He reports that Picasso was surrounded by doting women as a child, as was the custom in Andalusia.

Barcelona and Early Modernism

In 1895, Don José obtained a post at the Barcelona School of Fine Arts, and Picasso was admitted to the School's advanced classes. After two years, Picasso entered the Royal Academy in Madrid where he made little impression. After eighteen months, he returned to Barcelona to live with his parents.

He was to look back at the capital of Catalonia as his real home in Spain. He had learnt the Catalonian language. Barcelona was Picasso's initiation into avant-garde culture. It formed his conception of art.

Between early 1899 and spring 1904, Picasso developed his career in Barcelona. He was rapidly acknowledged as a rising star in *Modernista* circles and the group centred on the Els Quatre Gats tavern. He exhibited and his graphic work was published. The artists, writers, poets and critics who rallied round the banner of the *Modernisme* movement were diverse. Central to the ideology of the group, however, was a commitment to the language and culture of Catalonia and the claim that Barcelona and Catalonia were part of modern Europe, unlike backward-looking Spain and its capital, Madrid.

Anarchism and Modernism

The ideology of the group was then nationalist, modernist but also anarchist. After a period of terrorism, Spanish anarchism was turning to education as a means of creating a libertarian society. In the 1890s, it was fashionable among intellectuals in France and Spain. It opposed the power of the state with various models of social and workers' organizations. It saw the Church as the source of false and perverted doctrines and capitalism as exploitative and socially divisive.

Modernism in art is for the most part critical of industrial and economic modernity. It rarely celebrated the new age of electricity, tele-communications and the motor-car. In particular, the avant-garde art of the period opposed the spiritual and emotional ethos of the modern commercial and industrial culture. The positivist belief in scientific and technological progress carried with it a demotion of art and of all belief and experience not founded on utility or quantifiable experience. Modernism asserted art as a modern metaphysical value in the face of anti-metaphysical modernity.

This rejection had its artistic roots in both the English Pre-Raphaelite Movement, founded in 1848, and in 19th-century realism – in other words, in both images of a more spiritual past and of the lower social orders. Its contemporary models were the sinuous energy of Art Nouveau and the ethereal aesthetic of symbolism. One of the founders of *Modernisme* wrote: "We prefer to be symbolists and unstable, and even crazy and decadent, rather than fallen and meek... Common sense oppresses us; there is too much cautiousness in our land." Picasso was to say years later...

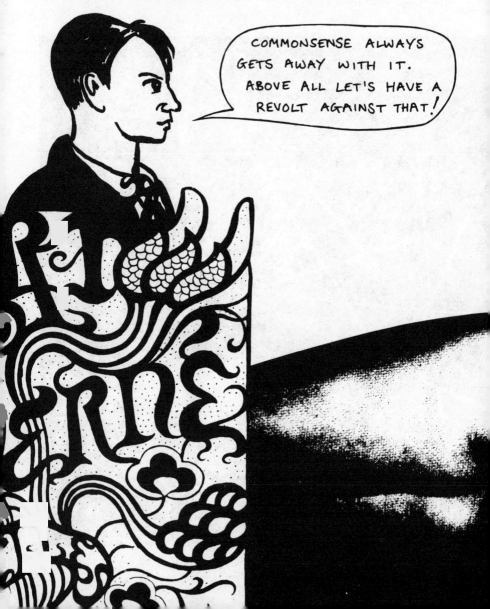

Early Influences on Picasso

Picasso's work between 1899 and 1904 is eclectic. One catches glimpses of stylistic devices and themes from recent art, but also from illustration and graphics. Art and illustrated political and satiric magazines from France, Germany and Britain were in circulation. Particular models for Picasso's own graphic work were Aubrey Beardsley (1872–98) and the Swiss illustrator Théophile-Alexandre Steinlen (1859–1923). To a degree rare in major 20th-century artists, Picasso remained a draughtsman; he drew with paint and he pictorially manipulated physiognomy like a caricaturist.

Current foreign ideas and literature were also in circulation. Translations of English and French articles on art were published in **Pel & Ploma**, a magazine to which Picasso contributed and in which exhibitions of his work were reviewed. He was moving in circles whose members read poets such as Charles Baudelaire (1821–67), whose **Les Fleurs de Mal** was very influential, and the philosopher Friedrich Nietzsche (1844–1900) whose **The Birth of Tragedy** was read avidly in artistic circles. It was the ideas associated with these writers that informed Picasso's practice and its aggression towards established culture.

Nietzsche's "Will to Power"

Nietzsche's ideas, or, more precisely, the understanding of them then current in avant-garde circles, provide the most useful single map for Picasso's fundamental conception of art. It was these Nietzschean ideas that he absorbed from the Barcelona milieu and continued to encounter in Paris. We can glimpse Nietzschean sentiments or ideas in many of Picasso's statements as well as in his work.

For Nietzsche the artist is central.

Picasso is quoted as saying in 1953...

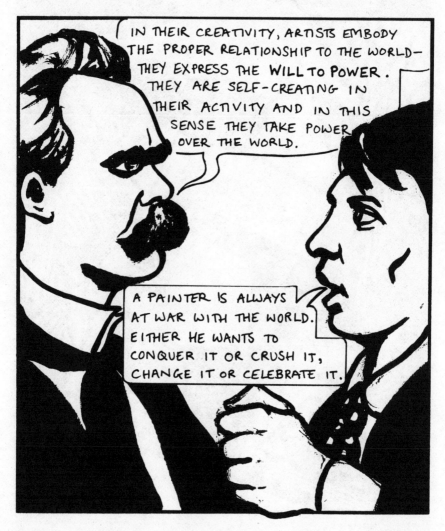

For Nietzsche, art must therefore be grasped in the terms of the artist not in terms of the audience and their pleasure and enjoyment. "It's not what the artist *does* that counts, but what he *is*," said Picasso in 1935.

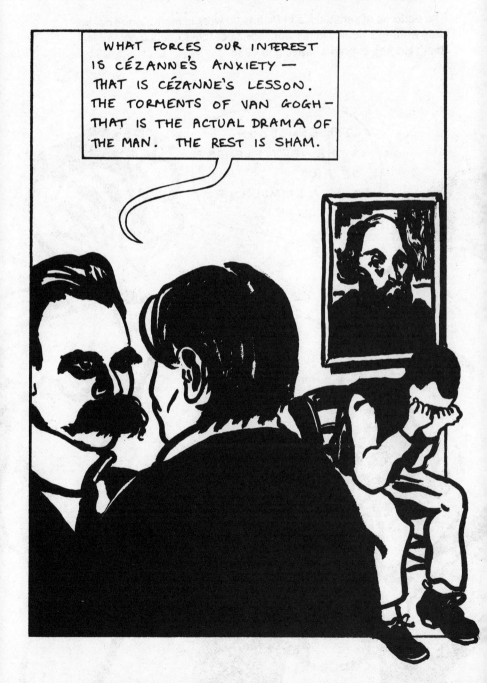

Nietzsche rejected the Christian aspiration for transcendence of sensual life. Truth for him was not to be discovered in the supersensuous.

The epitome of sensual life in Picasso's work is male sexual desire, thus women's bodies in his work speak of the authentic core of life itself. He was quoted as saying in 1935...

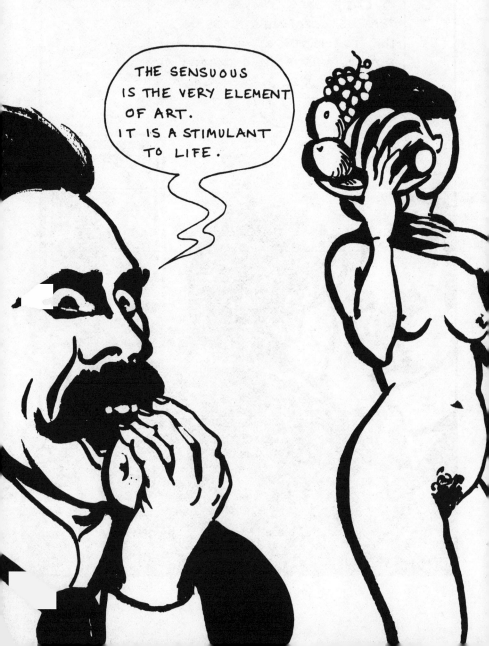

THE SENSUOUS
IS THE VERY ELEMENT
OF ART.
IT IS A STIMULANT
TO LIFE.

Art accepts the partiality and contingency of its truth rather than the self-serving claims to the universal truth of religion, science or common sense.

Picasso's son Paulo remembered his father's most constant refrain as "truth is a lie".

IT IS MY MISFORTUNE ~ AND PROBABLY MY DELIGHT ~ TO USE THINGS AS MY PASSIONS TELL ME. WHAT A MISERABLE FATE FOR A PAINTER WHO ADORES BLONDES TO HAVE TO STOP HIMSELF PUTTING THEM INTO A PICTURE BECAUSE THEY DON'T GO WITH A BASKET OF FRUIT.

WE ALL KNOW ART IS NOT TRUTH. ART IS A LIE THAT MAKES US REALIZE TRUTH, AT LEAST THE TRUTH THAT IS GIVEN US TO UNDERSTAND. THE ARTIST MUST KNOW THE MANNER WHEREBY TO CONVINCE OTHERS OF THE TRUTHFULNESS OF HIS LIES.

The Casagemas Incident

At the turn of the century, Munich and Paris were the most artistically avant-garde cities. The *Modernistas* in particular looked to Paris, and it was there that any ambitious artist had to go. Between 1900 and 1903 Picasso made three attempts to establish himself in Paris.

On the evening of Sunday, 17 February 1901, in Paris, a group of French and Spanish diners sat at a table in L'Hippodrome. One of the company rose, gave a speech and then handed some letters to the woman sitting next to him. She glanced at the letters, ducked under the table and hid behind another guest as the speaker took out a revolver. He fired at her, saying: "This is for you!" She fell to the ground, but the bullet had missed. He then turned the gun upon himself, adding: "This is for me," and shot himself through the forehead. The woman who recognized the letters as suicide notes was Germaine Pichot and the man Carlos Casagemas. For the previous eighteen months Casagemas had been Picasso's closest friend.

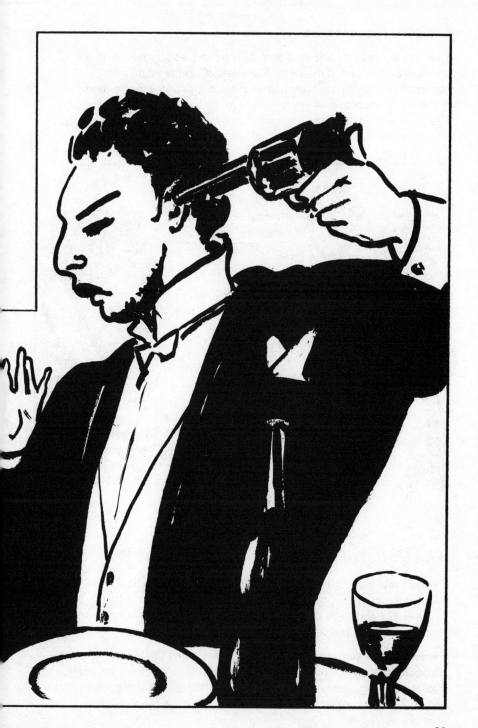

Casagemas was impotent.

This was not his first suicide attempt. The motives suggested for the attempted murder and his suicide are despair at his inability to consummate his love for Germain and her consequent return to her husband. It has also been mooted that he was in love with Picasso who was manoeuvring this sophisticated, cultivated but deeply troubled man out of his life.

The Burial of Casagemas and the Blue Period

Picasso returned to Paris in April 1901 for his second visit. The first had been in the company of Casagemas. In a studio they had shared, he painted *The Burial of Casagemas (Evocation)* and other works that commemorate Casagemas and inaugurate his **Blue Period**.

Picasso used colour to incite emotion rather than to give aesthetic pleasure. The dominant colours of *The Burial* are blue and the blue-derived hues, green and purple, with a few accents of ochre, white and red. The canvas is relatively large, nearly 146 x 89 cm.

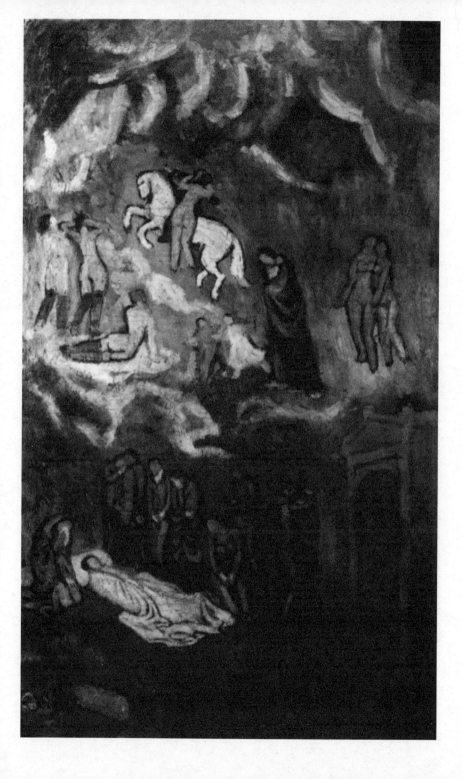

The painting is in the tradition of Spanish death allegories and owes something of its upwards swirling composition to the newly fashionable El Greco (1541–1614) and his *The Burial of Count Orgaz*. But the work mocks the tradition.

In the bottom half of the canvas reclines a white-robed body, figures in postures of grief and a mausoleum. In the swirl of clouds in the upper half is a group of prostitutes, identified by the combination of stockings and nudity, a mother carrying a baby and two children and on the far right two naked women. Above them on a white horse is the departing soul of Casagemas with his arms outstretched as in a crucifix. A third naked woman clings to him. Casagemas crucified by a whore, by sex.

The Casagemas work can tell us something of what Picasso was bringing to Paris from his years in Barcelona. His colour and form were symbolist in that they aimed to evoke rather than describe and by implication rejected the pictorial common sense of realism. The use of Christian iconography echoes back to Catholic Spain but also symbolist anti-materialism. However, sexuality as the theme of the work contradicts its Christian sources. It is blasphemous. It is a painting dominated by its subject matter, formally flabby and indecisive, an indulgent act of adolescent grief but for the disruption of the sacrilegious, the knowing play upon religious genre.

The American art historian Theodore Reff said of *The Burial* in a 1973 essay: "Obviously about love, the ultimate cause of Casagemas's death, the allegory centres on the contrast between two traditional types of love, sacred and profane, as embodied in the prostitutes and the mother and children." Unlike the traditional Christian allegory, however, there is no suggestion of the ultimate triumph of the sacred.

The characteristic works of the Blue Period are smaller, formally more coherent than *The Burial*. While colour remains insubstantial, ethereal and pessimistic, it is controlled by line. The lone self-absorbed figures, figures broken by the brutality of urban life. Picasso saw Paris through Baudelairean eyes.

> Gaping tatters in each garment prove
> Your calling is not only beggary
> But beauty as well,
>
> And to a poet equally "reduced",
> The frail and freckled body you display
> Makes its own appeal

The Blue Period paintings can be read as social criticism but also as adolescent pessimism. They depict passive victims and incite easy empathy, and in that sense they are sentimental, until their underlying eroticism suggests some recognition of their own corrupt motivation as flowers of evil.

"The Vertical Invader"

In spring 1904, Picasso left Barcelona again for Paris. He was to spend the rest of his life in France returning to Spain only on visits. He was twenty-three years old.

For some Marxist historians, for instance, Max Raphael (1889–1952) and John Berger (1926–), Spain's backwardness, the vestiges of its feudal and semi-feudal past, its lack of industrialization and its landed ruling classes are important in understanding Picasso. When he moved to France, he was a cultural outsider in a modern culture, a "vertical invader". It gave him an outsider's insight into modern culture, but deprived him of any vision of a modern alternative.

Berger describes Picasso's approach to art as akin to Spanish anarchism. According to Berger, anarchism flourished in Spain because Spain had an extensive administrative class left over from the high tide of Spanish imperialism in the 16th century. This immobilized class projected the memory of an idealized past collective into a future millennium. So, for instance, Picasso's visions of social harmony are invariably Arcadian rather than modern. A violent act of destruction would achieve this future collective. Unlike Marxism, Spanish anarchism ignores the processes of historical development in favour of a vision of the old order's sudden destruction. Berger quotes Picasso as saying, "a painting is a sum of destructions". However, as Marxism has failed to produce a new future other than as a nightmare, Picasso's anarchism and its own perceived failures has little against which it can be measured.

Le Bateau-Lavoir

Picasso rented a studio in Montmartre in what had been a piano factory. Now a warren of studios, this jerry-built wooden structure was christened the Bateau-Lavoir, or laundry boat, by Max Jacob (1876–1944) and André Salmon (1881–1969).

The poets Jacob, Salmon and the Polish-born Guillaume Apollinaire (1880–1918) were to be Picasso's closest companions in the next years and three of the most important poets of their generation. The group argued, read, wrote and recited poetry. "We made continual fun of everything," remembered André Salmon in 1935.

Humour in Picasso's work should not be underestimated. Jokes do many things: they play with words and disrupt stereotypes and moral expectations. They can speak of things normally suppressed: violence, aggression, sex and death.

The Influence of Jarry

Picasso had great admiration for the work of Alfred Jarry (1873–1907) with its fantastic, scatalogical and virulent humour. His own writing was much indebted to Jarry whose work he could recite from memory. "At the very heart of Picasso's work," writes Richardson, there is "his contradictory use of symbols . . . This perverse procedure may well have its source in Jarry, who sets up a symbol, knocks it down, up-ends it, reverses it, conflates it with other symbols in other contexts."

This appears in Jarry's ***Gestes et opinions du Docteur Faustroll*** (Deeds and Opinions of Dr Faustroll):

The River and the Meadow

The river has a big flabby face, made to be slapped by oars, a neck with many folds, blue skin with green down. In its arms, over its heart, it holds the little island shaped like a chrysalis. The meadow in its green dress falls asleep, its head in the hollow of the river's shoulder and neck.

Jokes and Hashish

Jokes, word play and satirical role-playing are ways of assaulting common sense. There are others. Apollinaire, Jacob, Salmon and Picasso smoked opium and hashish together, until Picasso gave it up after the suicide of a drug-addicted friend in 1908. Richardson suggests that it is likely that his use of drugs was, like his use of alcohol, moderate.

Throughout his life, Picasso kept the company of poets. He was to write poems and plays himself. The poets gave Picasso ways of talking about his own work which in turn could inform its subsequent making. Picasso worked and re-worked his motifs rather like a poet. His is an art of a mind fed by imaginative literature and the work incites us to interpret it as we might poetry. He was to complain in 1959, "so many painters today have forgotten poetry in their painting – and it's the most important thing".

What Picasso seems to mean is the poetry-like capacities of painting: images as having multiple meanings, and ideas and values signified by the qualities of signs. He did not advocate or practise the literal use of a pre-existing library of iconography. Picasso's art almost always refuses subordination, or perhaps hides its debt to any discourse, be it political, theoretical or literary. Poetry then as the denial of prose. Nietzsche had argued that art must be grasped in terms of the artist, and Picasso seeks to deny the spectator any other means.

Family of Saltimbanques and The Rose Period

Begun in 1904, *Family of Saltimbanques* was completed in 1905. A very large painting, over two metres in both dimensions, the cost of the paint and canvas would have been a major investment for Picasso at the time. X-ray examination of the paintings has revealed the residue of two other versions of the scene beneath its surface. There are many drawings, gouaches, drypoints and other paintings associated with the composition, its figures and themes. Many consider it the major work of Picasso's **Rose Period**.

These vagabond figures of clowns and acrobats are arranged in the foreground of a forlorn plane. Hills, clouds and sky are indicated in explicitly brushed ochres, whites and blues. On the right sits a young woman in a pink skirt, blue vest, white shirt and a florally decorated straw hat. Further back in a half circle stand five figures, their composition derived from the five fingers of hand: a little girl in a light pink dress holding a basket with flowers; a young dark-haired man dressed as Harlequin, the colours of his costume all darkened by black; the huge figure of the Saltimbanque all in red; beside him stands a boy perhaps in his late teens, naked but for briefs; and next to him a boy dressed in blue with a pink scarf. They are sealed off from the viewer's empathy by the enclosure of their arrangement and the darkness beneath their brows. We can barely see their eyes and the direction of their glances.

Outcast, moral and intellectual nonconformity is, in the poetry of Baudelaire, a condition shared by the poet and vagabond.

> A ragpicker stumbles past, wagging his head
> and bumping into walls with a poet's grace,
> pouring out his heartfelt schemes to one
> and all . . .

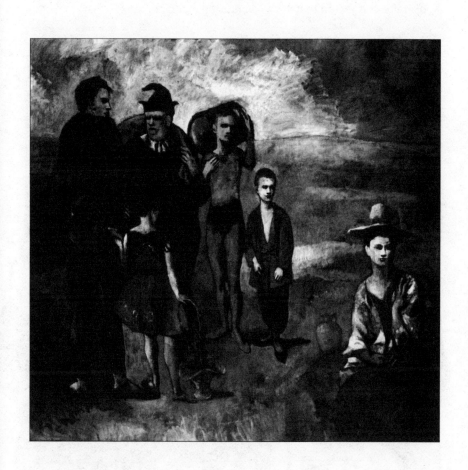

Self-Portrait as Harlequin

Both Salmon and Apollinaire used the figure of the Saltimbanque – the showman or mountebank – and the Harlequin as *alter egos* for the artist in their poetry. A number of suggestions have been made to identify the figures in **Family of Saltimbanques**, for instance, that the portly Apollinaire was the Saltimbanque, but this has been doubted. However, without doubt the Harlequin is a self-portrait of Picasso. It was a persona for himself and the artist in general he was to use again. Apollinaire suggested that it was an androgynous persona.

In 1905, Fernande Olivier (1881–1966) who had been working as an artist's model moved in with Picasso at the Bateau-Lavoir. They lived together for seven years. According to the American-born writer Gertrude Stein (1874–1946), Fernande had three topics of conversation . . .

However, she was a talented untrained artist and was to publish two books, *Picasso and His Friends* in 1933 and the posthumously published *Souvenirs Intimes* which came out in 1988. Vividly written, both are important sources on Picasso and his milieu. The delayed publication of the latter book was secured by Picasso's paying her a million old francs in the mid-1950s.

In May 1906, ended two years in Paris during which Picasso had experienced financial insecurity with periods of dire poverty. The dealer Ambroise Vollard bought most of his Rose Period canvases. He had been selling work to other dealers, often at pitiable prices, and to Russian, German and American private buyers, who included Gertrude Stein and her brother Leo. He was largely ignored by French collectors.

Les Demoiselles d'Avignon

Between late April and early June 1907, Picasso worked on a canvas just over 2.4 metres high and nearly as wide. This large work's production was preceded by over sixty drawings and gouaches some going back to the winter of 1906.

It was André Salmon who some years after its completion named the painting *Les Demoiselles d'Avignon* after a brothel in Carrer d'Avinyó (Avignon Street) in Barcelona.

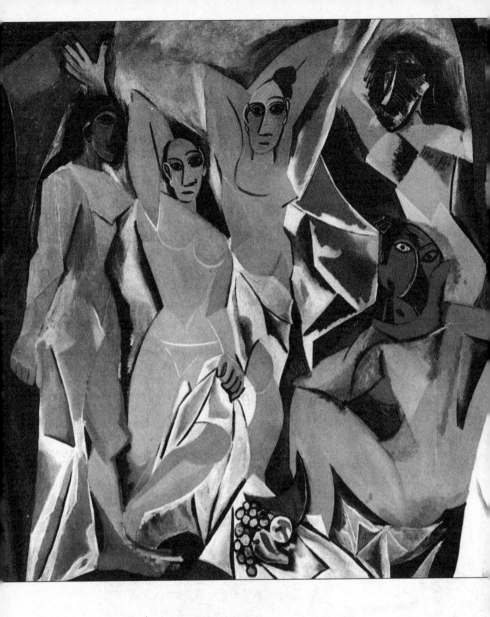

It is one of the most important paintings of the 20th century, but for thirty years it was rarely seen in public. The first reproduction of it did not appear until 1925. Picasso kept it in his studio until he exhibited it for the first time in 1916. It was sold to a private collector in 1922. In 1937 it was bought by the Museum of Modern Art, New York, after being exhibited in Paris and New York.

Matisse's Reaction

The legendary status of the work was conveyed by the reactions of those who had seen it. Henri Matisse detested it.

In a sense, he was right. In 1905, he and his group had caused a sensation at the annual Salon and were disparagingly labelled *Fauves* or beasts, but he had become the acknowledged leader of the avant-garde.

A series of large paintings of bathers by Paul Cézanne (1839–1906) had recently been seen in Paris. These compositions depicted groups of naked and partially draped women. Cézanne's reputation and influence were growing.

In 1906, Matisse took up the subject of partially draped and naked figures in nature in a large painting of women disporting themselves in an Arcadian landscape which he called *Joy of Life*. Although attacked for its unnatural use of colour and schematic drawing, the work constituted a modern classical vision in its sinuous lines and open space. *Les Demoiselles d'Avignon* may have been Picasso's answer to *Joy of Life*. Whereas *Joy of LIfe* is idyllic and sensual, *Les Demoiselles* is jagged, crowded, urban and sexual.

Reactions to *Les Demoiselles*

George Braque (1882–1963), who with Picasso was to pioneer Cubism, on first seeing *Les Demoiselles* said, "It is as though we are supposed to exchange our usual diet for one of tow and paraffin." The metaphor was apt: the work refuses good taste. The valuing and advancement of pleasurable painterly effects were central to Matisse's group with which Braque's work was then aligned. It is a misleading cliché to distinguish Picasso from Matisse by describing Picasso as a draughtsman and Matisse as a colourist. Both used colour expressively rather than descriptively.

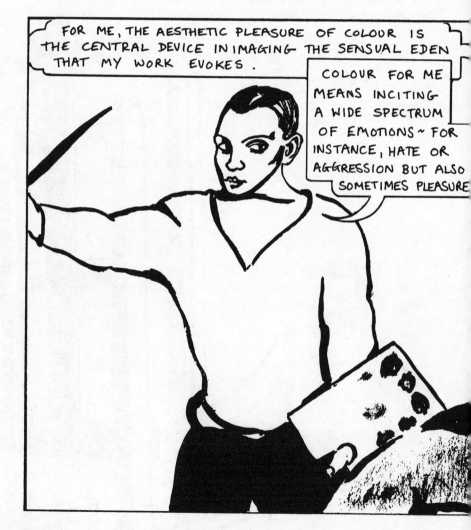

Initially, **Les Demoiselles d'Avignon** was valued as heralding the breakthrough to Cubism. Daniel-Henry Kahnweiler, who was to become the dealer for both Picasso and Braque and a close friend during the Cubist period, wrote in 1915 in a book published in 1920 that the work was unfinished and failed to reconcile its disparate pictorial languages.

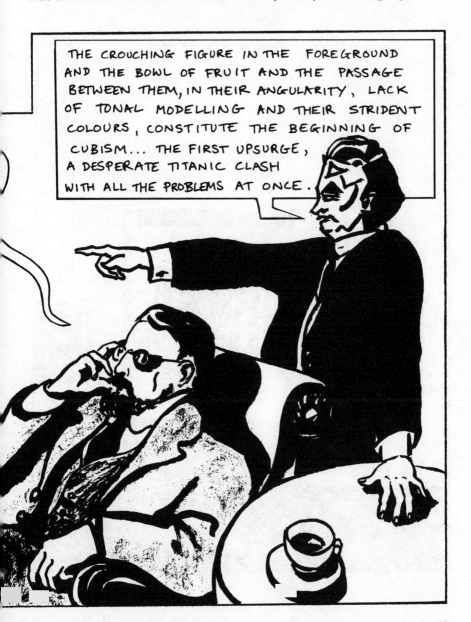

Picasso and Institutional Modernism

The tendency in art history was to see it as "a transitional picture, a laboratory, or, better, a battlefield of trial and experiment", to quote the words of Alfred H. Barr (1902–1981), the first Director of the Museum of Modern Art in New York. Clearly, he thought the work important nevertheless, for he initiated its purchase by MOMA.

At the end of the 1920s, Barr created in MOMA what was to become, with the dismemberment of the German public galleries in the Nazi era of the 1930s, the paradigm of the modern art museum. Picasso and Matisse are the two major artists in MOMA's story of 20th-century art. Barr institutionalized Picasso's position. In France, no public collection bought his work until after 1945. For Barr, the history of modern art was primarily a history of formal development. He laid out the museum, hung the work and wrote about it accordingly. This kind of account tends to suppress questions of meaning and of the social and political context of art. In the last thirty years, this view has come to be called modernism in the professional discourse of the art world, but the word has other prior usage and connotations.

Picasso's "Primitivism"

Les Demoiselles d'Avignon brings together elements from Picasso's previous two years' work and its sources: for instance, the insecurity of the space and explicit surface composition from Cézanne. The face of the left-hand figure echoes ancient classical Iberian sculpture. The almond-shaped eyes, the line of the brows that continues down to describe the nose, are the stylizations he used in a portrait of Gertrude Stein in 1906. The faces of the two right-hand figures are derived from his attention to African masks. These last two sources in what was thought "Primitive Art" connoted the idea of primal emotion and the absence of "civilized" inhibitions.

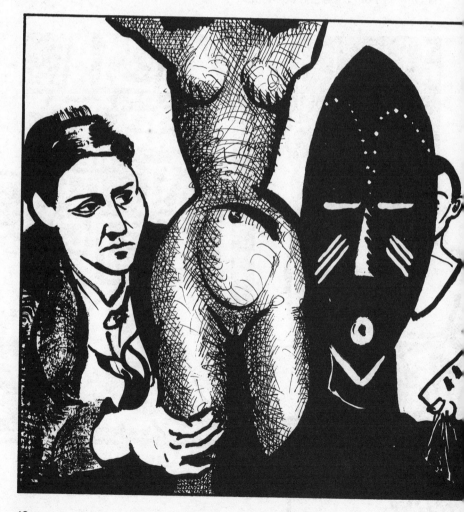

A scholarly willingness to revalue the work for what it is, rather than for what it leads to, re-emerges with an essay, "The Philosophical Brothel", published in 1972 by the American art historian Leo Steinburg. "The picture is a tidal wave of female aggression; one either experiences the *Demoiselles* as an onslaught, or shuts off." In Nietzsche's words in *The Birth of Tragedy* . . .

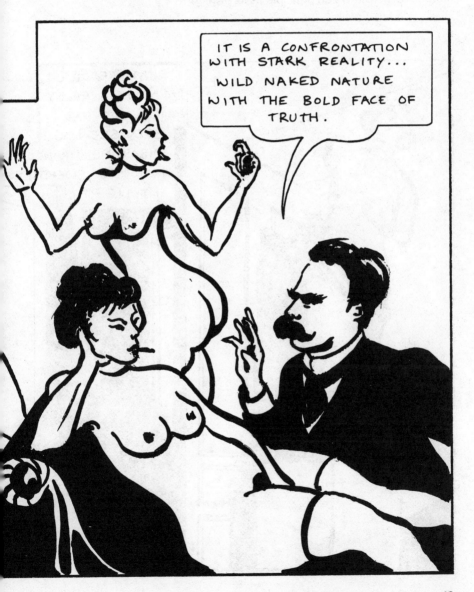

Nietzsche's View of Greek Art

Nietzsche argued that in Greek tragedy the ordered "Apollonian" aspect was pitched against the irrational and barbaric reality of the "Dionysian". In arguing for the necessity of the chaos of desire for the achievements of Greek art, Nietzsche shattered the cornerstone of institutionalized European high culture.

As *Les Demoiselles d'Avignon* exemplifies, the avant-garde embraced the Dionysian principle as its own.

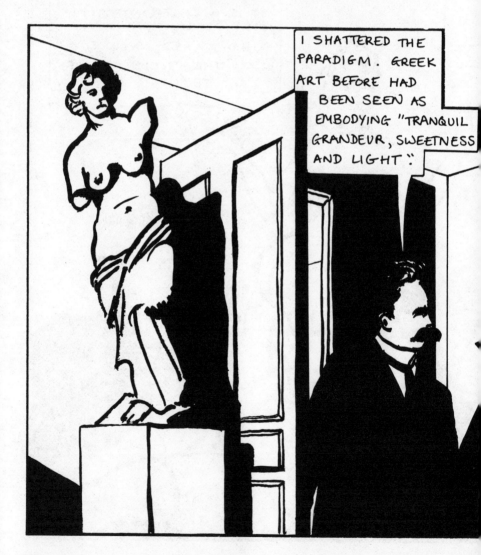

The Viewer Involved

Steinberg argues that the painting was originally an allegory of involved and uninvolved confrontation with sex. In the middle of early drawings for the painting was a participant male customer; on the left, an observing male entering, either a medical student or artist, carrying a book and a skull. These figures were removed to make the *viewer* an involved party.

Devices are used to thrust the painting into the face of the viewer. Steinberg describes the penetrative scheme of the composition: for instance, the viewer stands before a triangular table that thrusts up from the bottom of the picture. The left figure of the two central women is seen as if she were lying down beneath us. "In one sense the whole picture is a sexual metaphor," wrote Steinberg. "But it is also the opposite, a forced union of dream image and actuality ... Explosive form and erotic content become reciprocal metaphors for each other."

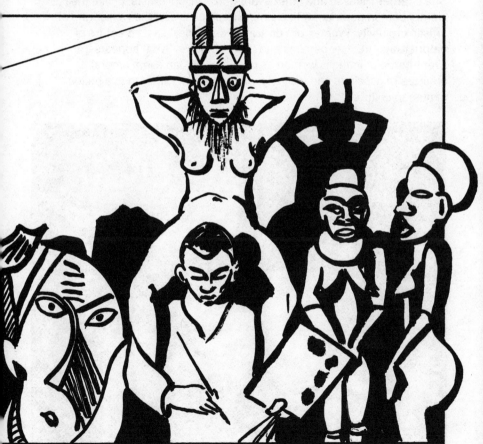

The "New Art History"

In the last twenty years, the "New Art History" has received academic validation. In one of its aspects, it takes a strand of Marxist cultural analysis in which art is understood as part of the ruling ideology, rather than as transcending the values and beliefs of the dominant class. It sets out to show how art is brought into being within and replicates the racial, gender and class ideologies of the society in which it was made. Because these analyses fail to recognize the intelligentsia as having a particular social, economic and ideological history, they tend to turn art into a general social symptom and are inattentive to the specific context of art production. For instance, the American feminist art historian Carol Duncan wrote of **Les Demoiselles** in a 1973 article ... "No other modern work reveals more the rock foundation of sexist anti-humanism or goes further and deeper to justify and celebrate the domination of women by men."

She charges Picasso and other avant-garde visual artists, unlike their literary contemporaries, with claiming male desire as the well-spring of artistic creativity. Women are portrayed as "other", as a creature of nature rather than as persons and part of culture. What appears in avant-garde painting is women as primitive, as "an alien, amoral creature of passions and instincts, an antagonist rather than a builder of human culture".

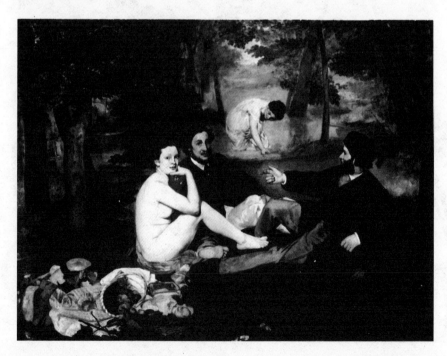

"What is remarkable about this work", writes Duncan of *Les Demoiselles* . . .

... IS THE WAY IT MANIFESTS THE STRUCTURAL FOUNDATIONS UNDERLYING BOTH THE 'FEMME FATALE' AND THE NEW PRIMITIVE WOMAN.

This is only denigratory if you hold to the hierarchy which puts "transubstantiating" culture above the physical substantiality of nature. As a Nietzschean, this was not Picasso's position, on the contrary. However, it is undoubtedly male desire which he takes as the authentic core of life. In *Les Demoiselles* the suggested androgyny of the Blue and Pink periods is gone. Now his work, for the most part, presupposes a male heterosexual viewer; but then, the presuppositions of a work of serious art are not the limitations of its meaning. Further, it would be a stupefying idea that involvement in an imaginative work is limited to those of the same gender and proclivity as the author and its presupposed viewer.

David Lomas in a 1993 article argued that in breaking with the classical ideas of beauty in *Les Demoiselles*, Picasso deployed racist deformities derived from physical anthropology (or anthropometrics) with its physiognomic "studies" of "degenerate types", such as prostitutes. He quotes Picasso...

He ends his essay: "What perhaps Picasso could not have realized was the extent to which, even within the revolutionary format of *Les Demoiselles d'Avignon*, he was in fact playing by dominant cultural rules." It can be argued that Picasso was playing *with* rather than *by* the rules and by so doing de-familiarizes them.

Formal Primitivism

To return to the formal significance of **Les Demoiselles** and its use of "primitive art": it provided pictorial devices for depicting an idea of an object or a figure rather than its optical appearance as schematized by post-Renaissance Western art. It served to extirpate those pictorial devices derived from and evocative of direct observation, such as naturalistic colour, coherent perspective and light and dark deployed to suggest the fall of light upon a form. Art historians have described this as a shift from the perceptual to the conceptual.

Le Douanier Rousseau

These "non-perceptual" devices were not only derived from ancient or distant sources. The features of the two central figures of **Les Demoiselles** have the simplicity of newspaper caricature or cartoons. Further, Picasso admired and had bought a work by the contemporary primitive painter, Henri "Le Douanier" Rousseau (1844–1910), in whose paintings each object has an independent life rather than being integrated into an envelope of space and light.

In November 1908, Picasso organized a mock dinner in honour of Rousseau at the Bateau-Lavoir. After dinner, Apollinaire made a solemn eulogy, André Salmon read a poem in honour of Rousseau, toasts were drunk. When Rousseau replied, he spluttered with pleasure and then played tunes on his violin, and Salmon, according to Fernande Olivier's account . . .

In her account of the event, Gertrude Stein, much to Salmon's chagrin, does indeed report him as drunk and violent.

'PRETENDED DELIRIUM TREMENS TO FRIGHTEN THE AMERICAN LADIES PRESENT.'

Cubism

All in all you're tired of this antique world
O shepherdess, Eiffel Tower, the flock of bridges is bleating this
 morning
You've had enough of living in Greek and Roman antiquity...
You read prospectuses, catalogues, posters all loudly singing
That is your poetry this morning, and for prose there are the
 newspapers
There are the dime serials full of cops and robbers...

 From *Zone*, Guillaume Apollinaire, 1913.

In 1908, Georges Braque submitted his recent paintings to the Salon
d'Automne. They were rejected. Matisse was on the selection jury and
referred to them disparagingly.

The critic Louis Vauxcelles in reviewing the same paintings in
November, when shown at Kahnweiler's gallery, also spoke of cubes
and Braques' work in the 1909 Salon d'Automne referred to
"bizarreries cubiques". From these dismissive descriptions the term
Cubism was coined.

Picasso, Braque and Others

John Berger argues that the period between 1908 and 1913 are the exception in Picasso's working life. "After *Les Demoiselles* Picasso became caught up in what he had provoked . . . he became part of a group who, although they did not formulate a programme, were all working in the same direction . . . It is also the one period of his life when his work (despite his denial of this) reveals an absolutely consistent line of development." Other Parisian artists shared some of the concerns that gave rise to Cubism and helped to elaborate its potentialities.

In the winter of 1908–9, Braque and Picasso became close friends and colleagues, "like two rock climbers roped together", as Braque was to put it. On an almost daily basis they inspected each other's work and together visited exhibitions, worked outside of Paris in rented accommodation and when separated they corresponded. At the height of their relationship in 1911, it is difficult for the non-expert to distinguish the paintings of one from the other.

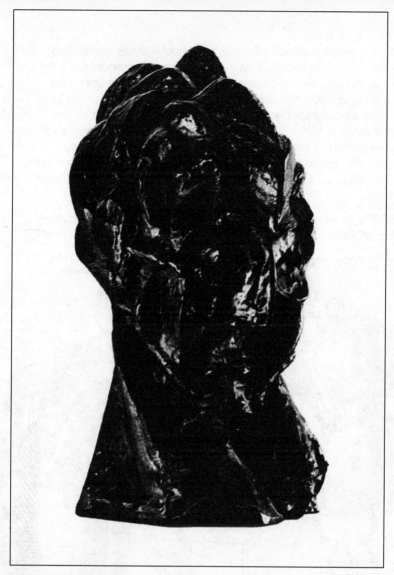

Head of a Woman

It is argued that Picasso's first stylistically integrated Cubist work is not a painting but a sculpture. The paintings presented, in a fairly conventional space, geometricized figures and objects. In a sculpted head alone, the problem of contextual space did not arise. *Head of a Woman (Fernande)* was made in the autumn of 1909. Throughout the rest of his life, Picasso periodically returned to sculptures as an activity integral to his painting, as another means to articulate his current concerns. Both informed each other.

Modelled in clay and then later cast by way of a plaster mould into multiple editions in bronze, *Head of a Woman (Fernande)* uses the schematizations of early Cubism: the planes of the face are either flattened or consistently curved. They approximate to Cézanne's advocacy that objects be simplified to the basic forms of "cones, cylinders and spheres". This rough geometrication replaces the subtle, edgeless form of a head. But the geometry is re-complicated by different viewpoints seen simultaneously. For instance, the edge of the jaw and the plane of the cheek it contains seem to belong to different moments.

Head of a Woman (Fernande) was made from portraits done while Ferande Olivier and Picasso were staying in Horta de Ebro.

In the autumn, they moved from the Bateau-Lavoir and Montmartre to a studio apartment in the Boulevard de Clichy in Montparnasse.

The period in which Picasso and Braque worked closely together is divided into two: Analytic Cubism from 1910 to 1912 and Synthetic Cubism which starts in 1912 and continues in both men's work after their separation in 1914. There is a radical difference between the work in these two periods. It is rather misleading that they are both called Cubism.

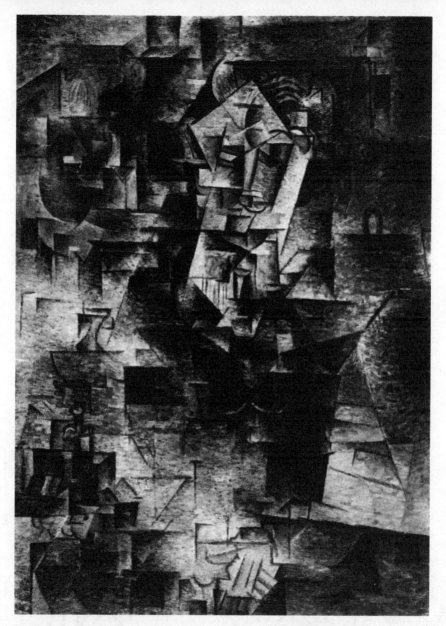

Analytic Cubism and *Portrait of Kahnweiler*

Analytic Cubism

Analytic Cubism deconstructed the syntax of realism. It broke the rules
of conventional arrangement of realist painting and sculpture. In other

words, Picasso re-configured painterly signs that evoked the perceptual. He also returned to, but re-cast, painterly aesthetic unity. He solved the problem of figure and context by making both equally spatially ambiguous. This was the new aesthetic unity.

Portrait of Daniel-Henry Kahnweiler was painted in the autumn of 1910. It is as if a series of geometrically schematized portraits have been selectively imposed one upon another. Each of these constituent portraits uses the vocabulary of realism in the sense that objects are described by tonal gradations – by light and dark. Tonality describes light falling upon a plane and thereby suggests a pictorial space, a space with light in it and into which we can imaginatively enter.

In *Portrait of Daniel-Henry Kahnweiler*, this realism is fractured by a number of counter devices. Pictorial space is not abolished, rather it is made inconsistent. The relative position in depth of areas is unstable, active. The way that light falls upon surfaces is inconsistent; the contradictory distribution of light and dark precludes a coherent three-dimension space. The brush marks are uniformly horizontal which creates an explicit picture plane. In other words, the eye does not just pass through the surface of the painting to the fictional space beyond. The surface is invoked as an optical presence, as a part of the active

space of the painting. The geometrification of objects produces straight lines which both simultaneously suggest the edge of planes in depth and sit on and pattern the picture plane. Further, these planes and their edges seem to interpenetrate each other, suggesting transparency. But once we give up any attempt to read the painting in conventional representational ways then we can see its pictorial coherence: there is a rigour to its spacial patterning, it has a sense of pictorial unity.

Marketing Cubism

The subject of the portrait, Kahnweiler, was the first major patron of the Cubism of Picasso and Braque.

By 1912, he had an exclusive contract to buy the work of Picasso and Braque. His strategy for promoting their work was to exhibit abroad, show particular works in his gallery, keep them in stock but not provide them for one-person exhibitions. You had to be in the know to see much of their work. It was marketed to an initiate élite of buyers. The degree to which Picasso had the more established reputation and more regular buyers than Braque is indicated by Kahnweiler's paying three or four times as much for his work than Braque's

Apollinaire in Prison

In 1907, Picasso had bought two Iberian heads from a friend of Apollinaire, Géry Piéret. Piéret had stolen them from the Louvre. When, in 1911, the *Mona Lisa* was stolen from the same museum, Piéret returned anonymously another statue he stolen in the hope of getting a reward. His identity was discovered and he was suspected of the theft of the *Mona Lisa*. He fled Paris.

Apollinaire and Picasso, as known associates of Piéret, panicked. As foreigners, both feared losing their permits to stay in France. They anonymously returned the stolen statues that Picasso had bought, but Apollinaire had helped Pièret leave Paris. The police discovered this and Apollinaire was arrested on suspicion of involvement in the theft of the *Mona Lisa* and for aiding Piéret. His arrest hit the headlines. Picasso was interrogated. He denied knowing the statues were stolen and declared Apollinaire to be "the greatest living poet". Piéret, on reading of Apollinaire's arrest, wrote a letter of confession, and so after four nights in jail Apollinaire was released.

Synthetic Cubism

Synthetic Cubism developed ways of signifying things by largely
escaping recourse to the realist conventions of Western high art. It used
the fact that visual signs can have little or no resemblance to what they
are taken to signify. "It is convention that gives signs their meaning,"
as Picasso put it himself in 1945, and perhaps overestimating the
arbitrariness of visual iconic signs as compared to verbal signs.

Guitar

In October 1912, Picasso made a cardboard maquette which survives
only in photographs taken in his studio at the end of that year. *Guitar* is
a sheet metal version whose precise date of construction is disputed,
but is located either in 1912 or 1913. The maquette may be his first
Synthetic Cubist work. This version is assembled from crudely cut
pieces of sheet metal and a piece of stove piping. It consists of
elements that if separated would in no way suggest a guitar. In
Synthetic Cubist painting, the organic unity of chiaroscuro abandoned,
and the traditional carving or modelling techniques of sculpture are
replaced by construction, the assemblage or montaging of elements.
Although different aspects of a guitar are suggested, it is not a
systematic representation, and there are parts which even in this
combination have no element of resemblance to a guitar. Furthermore,
where there is resemblance, it is to a drawing or a silhouette of a guitar

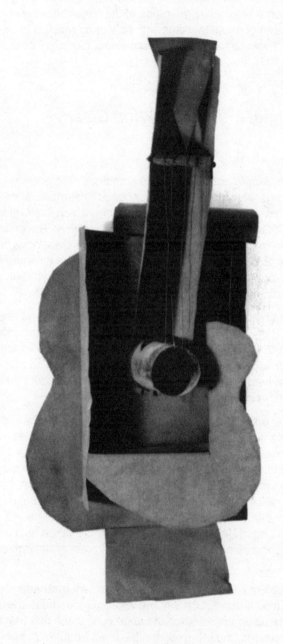

rather than to a guitar. At times, positives suggest negatives: in some African art, eyes are indicated by pegs, and here the sounding hole is a tube rather than a hole, while the plane of the finger board is concave. By a combination of aspects, some with little or no relation to visual appearances, Picasso has made a complex sign for a guitar.

Guitar, Sheet Music and Wine Glass

Guitar, Sheet Music and Wine Glass combines different ways of signifying things. Newspaper, wallpaper and sheet music are indicated by actual fragments, and the glass by drawing, which itself refers more to a diagram of a glass than a realistic representation. The guitar itself is signalled by an irrational combination: there are disparities of scale and relationship between the elements. Within one is the imitation of a material, or wood, whereas in the other parts colour is without any justification in naturalism.

The play does not stop there. This is a café. If we ignore the absence of perspective, the viewer can be mapped as sitting at a table with the newspaper and a glass of wine in front of him or her. The wallpaper is a tablecloth, its edges indicating the edges of the table. The guitar and the music are heard, not seen. All this is suggested by contiguity, by signs put into proximity.

The play goes on into words. *Le Journal* was a popular Parisian newspaper. In his *papier collé*, Picasso used parts of its titles many times, but never in its entirety. There is a "kind of multiple verbal–visual reading of similar sounds and letters (*joie* = joy; *jouer* = to play; *jouir* = to enjoy or, in sexual slang, to come) that we can trace in Picasso's metamorphoses of *Le Journal*", wrote the American art historian Robert Rosenblum in 1973. The headline in the newspaper, "La Bataille s'est engagé[e]" (The Battle is Joined), is taken as a message in the friendly rivalry between Braque, the inventor of the *papier collé*, and Picasso.

Synthetic Cubism was more radical and important than Analytic, not least for Picasso himself. Of his many vocabularies, the flatness, cut-out and constructed appearance of *papier collé* is the one that reoccurs most in his painting and assemblage, his most frequent method of making sculpture.

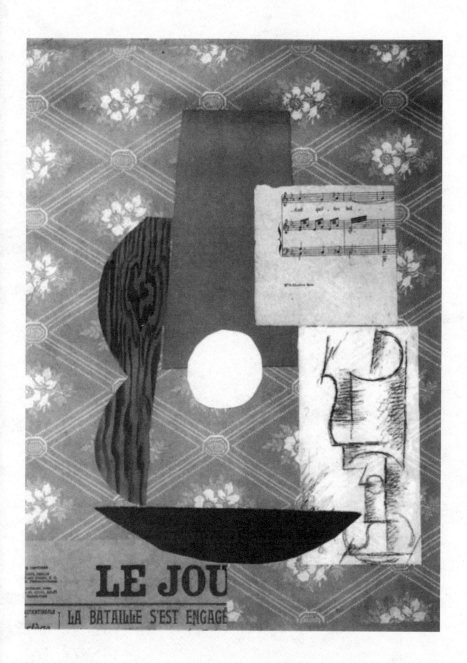

The Effects of Cubism

What was the significance of Cubism? First, it created forms of pictorial coherence that appeared radically unlike any precedents in Western Art. Because of this difference alone, it appeared distinctly modern. Cubism came to signal modern visual style, a break with the past, an overthrow of the power of tradition. Second, some of its devices seemed to connote an art born of the machine age; for instance, the geometrification of Analytic Cubism and the inexpressive, cut-out procedures of Synthetic Cubism.

The Italian Futurists

However, the best way to indicate the significance of Cubism is to
describe some its uses by other artists. For the Italian Futurists, who
had established themselves as a group in 1909, their encounter with
Analytic Cubism on a visit to Paris in 1911 was to transform their work.
On their return to Milan, they re-painted past work as well as making
new works deploying Cubist devices. Modernity was to be signalled by
Cubist geometrification, simultaneity of view was to be read as
movement and speed and as a means to gather the totality of an
experience.

Mondrian

For other artists, Analytic Cubism at its most abstract or hermetic was a stepping-stone to radical abstraction. Piet Mondrian (1872–1944) came to Paris in 1909 and took from Analytic Cubism a rigorous monochromatic and linear formulation of his subject matter. He developed a view in which the experience of the unity of the picture plane, animated by its asymmetrical division, became a vision of the developing process of the Spirit, the Hegelian *Geist*. Mondrian had a mystical theosophical view of art.

Tatlin and Constructivism

The Russian Vladimir Tatlin (1885-1953) visited Paris in 1913 and saw Picasso's Synthetic Cubist wall sculptures. On return to Moscow, he made his first abstract *Relief Construction* in the winter of 1913–14. He took from Synthetic Cubism the method of assemblage in which diverse materials are brought together. These sculptures were constructed rather than carved or modelled. They laid the foundation for Russian Constructivism. Thus the anonymity and inexpressive methods of Synthetic Cubism became a precedent for the idea of artist as engineer in which the world is constructed anew from zero.

Аппарт в обтяжке

Летатлин

Dadaism

Picasso's work was included in one of the first Dada cabarets in Zurich in 1916. *Papier collé* and the Synthetic Cubist wall sculptures anticipated Dada collage. Cubism was a source for the costumes used in Dada stage performances. But perhaps the most important contribution to Dada was the impurity of Synthetic Cubism, its evocation of street and café life, its use of material from mass culture, for example, newspapers and references to popular songs.

Cubism broke with the high art purity advocated by the Symbolists, the painterly aestheticism of the Fauves and the subjectivism of Expressionism. It was, in its materials and methods, a subversion of the status of high art. In this, it prefigured Dada as *anti-art*.

MoUvEmEnt
DADA

BERLIN, GENÈVE, MADR~~~~~~~~ ~~~~ORK, ZURICH

PARIS,

Explaining Cubism

Cubism has been absorbed into the very marrow of 20th-century art, architecture and design. These brief accounts of artists' use of Cubism are only indicative. To write a full account of Cubism and its ramifications would be to write about much of what is considered to be the important art of the 20th century.

Picasso and Braque never explained Cubism. Their silence has been filled by the writings of their friends, critics and subsequent generations of writers on art.

Even if we look to those close to Picasso and Braque, we get conflicting accounts. Some argued that Cubism showed things as they are rather than how they appear. This rested on the philosopher Immanual Kant's distinction between Phenomena, things as they are perceived by the human faculties, and Noumena, things as they are in themselves. Cubism, it was claimed, came closer to things as they are in themselves. Kahnweiler, for instance, writing in 1915, claimed: "They [the Cubists] endeavour to represent the primary, or most important qualities, as exactly as possible." In these arguments, Cubism is a new kind of realism in the sense that it sees beyond mere appearance to a reality beneath.

Cubism's Superior Reality

The more Nietzschean view was that Cubism asserts the will of the artist through his taste, it creates reality. Cubism overthrows the common-sense vision of the crowd and creates the truth of the individual artist's will, the reality of the artist's vision.

In 1912, two painter members of the Cubist milieu, Albert Gleizes (1881–1953) and Jean Metzinger (1883–1956), published an article entitled "Cubism". In the closing paragraphs, they wrote: "For the partial liberties conquered by Courbet, Manet, Cézanne and the Impressionists, Cubism substitutes an indefinite liberty . . . Henceforth, objective knowledge at last regarded as chimerical, and all that the crowd understands by natural form proven to be convention, the painter will know no other laws than those of taste . . . A realist, he will fashion the real in the image of his mind, for there is only one truth, ours, when we impose it on everyone."

Late Modernism in America

In the Modernism of post-1945, Cubism was seen as central to 20th-century art. The most influential Modernist critic was the American Clement Greenberg (1909–1994). His argument was much indebted to Alfred Barr's view and collection of Picasso's work in MOMA and the formal analysis of the painter and theorist Hans Hofmann (1880–1966) who had been in pre-First-World-War Paris. From Hofmann, Greenberg took the requirements of the "integrity of the picture plane" and "push and pull". The integration of the picture plane meant that no part of a painting should make an illusory hole in the picture plane; rather, any suggested space must be in active optical play with the picture plane. These animated relationships he called "push and pull".

Greenberg argued that Modernist art gained its vitality by exploring its own intrinsic means. In this critical age, each art was impelled to extirpate all that was irrelevant to it and work out the implications of its own given material nature. For painting, that meant exploring its flatness as pictorial space: so not the literal flatness of its surface, but the pictorial flatness of the picture plane.

Greenberg wrote in 1959 that Picasso and Braque "were more crucially concerned, in and through Cubism, with obtaining *sculptural* results by strictly non-sculptural means; that is, with finding for every aspect of the three-dimensional vision an explicitly two-dimensional equivalent, regardless of how much verisimilitude might suffer in the process."

In Greenberg's criticism, his reading of Cubism was the keystone. The failure to work within Cubist space was grounds of his demotion of such artists as Kandinsky and his dismissal of the pictorial realism of much Surrealist painting. It was also the grounds for his criticism of some of Picasso's later work.

The Call to Order

In 1926, the poet, draughtsman, playwright, film director, publicist and socialite Jean Cocteau (1889–1963) published a book of collected essays *Le Rappel à l'ordre* (The Return or Call to Order). It reprinted an article on Picasso. The phrase has come to refer to ideas and art practice that came to the fore in the latter part of the First World War and dominated the early 1920s. Picasso and his relationship with Cocteau are a central part of the story.

War was declared between France and Germany at the beginning of August 1914. Picasso was staying in Avignon and the Braque and Derain families were nearby. Braque and Derain were called up for service in the army. Picasso went to Avignon station to see them off. Years later, when both had returned from the war, Picasso was to say ...

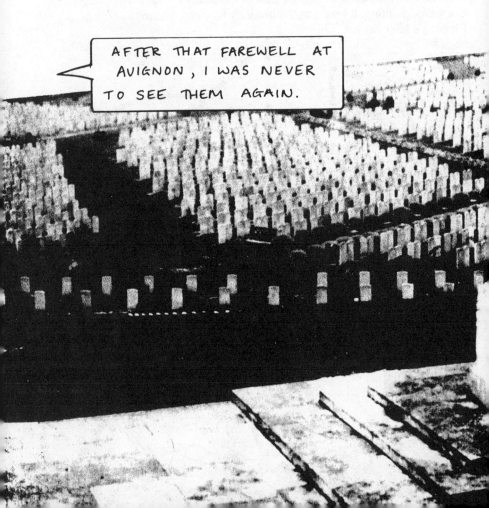

The First World War was a bloody punctuation to an extraordinary period of art practice in Paris of which Picasso was a central figure. What he never found again was the collective endeavour he had shared with Braque and to a lesser extent with Derain and other artists who explored the potentialities of Cubism. He was further set apart from most of his contemporaries and colleagues by not experiencing that terrible war as a soldier, for Spain remained neutral.

First Meeting with Cocteau

By the beginning of 1914, Picasso was a famous and relatively wealthy artist. He had sufficient savings to survive the hiatus in the art market which the war brought. He had parted from his companion of the bohemian years, Fernande Olivier, in 1912, and lived with Eva Gouel, with whom he had developed a liaison in the winter of 1911. They lived in various parts of Paris.

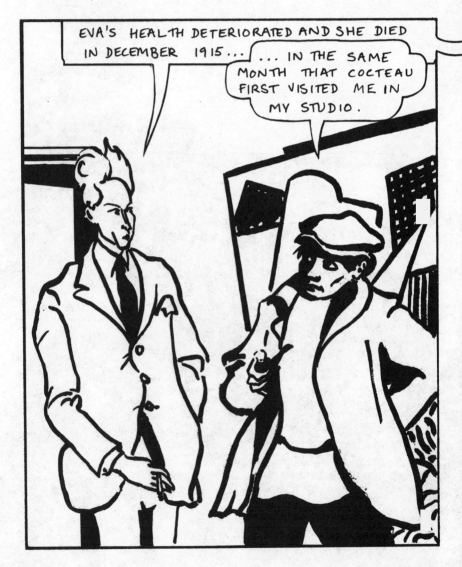

Parade

In early 1916, Cocteau was commissioned by Sergei Diaghilev (1872–1929), the director of the Ballets Russes, to write *Parade*, as scenario for a ballet.

He agreed but introduced more visual elements including three figures wearing elaborate structures. One of them, for instance, "the American Manager", was a three-metre-high combination of skyscrapers, a megaphone and a man in a top hat – it was a Cubist collage on legs.

I ASKED PICASSO TO DESIGN FOR THE BALLET.

In 1917, Picasso spent eight weeks with Cocteau in Rome working on the décor and the costumes for **Parade** and visiting museums and galleries in Rome, Naples and Pompeii. He attended the rehearsals and performances of the ballet.

Eighteen months later in Paris he married her. In 1921, they had a son, Paulo. He was marrying into the fashionable world of the Ballets Russes, then the rage among the sophisticated rich. Furthermore, "thanks largely to Cocteau," says John Richardson, "he moved to a smart apartment and took to frequenting the Proustian world of 'le tout Paris'."

Radical Chic

The British art historian Christopher Green, in his ***Cubism and its Enemies***, published in 1987, wrote, "As Cocteau himself put it, he had aimed to bring the monied stylishness of the 'artistic right' together with the radical audacity of the 'artistic left' and he saw 'the sumptuous decorative aesthetic' of Diaghilev's Ballets Russes as the vehicle for achieving this. ***Parade*** was an attempt to win a public by charm and surprise and was itself a parable of the relationship between the avant-garde and the public (the relationship it set out to transform): its theme was the failure of a troupe of street performers to persuade the audience to enter and see their show."

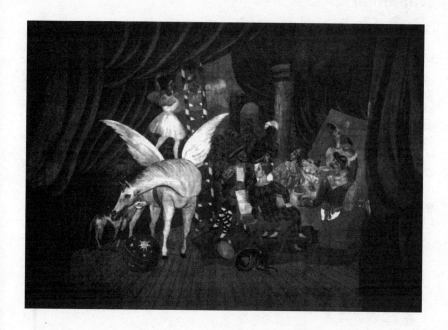

Drop Curtain for Parade

Picasso's *Drop Curtain for* Parade was in sweet green and reds. It depicts a circus troupe. In contrast to *Family of Saltimbanques* of 1905, they do not stand in a bleak landscape, seemingly unengaged with each other, but sit around a table with food and drink in a curtained space with a view out to ruined arches. Like the earlier painting, the Harlequin has his back to the viewer and we see his face in profile, but now he gazes at the ballet dancer, his posture elegant and animated. She stands upon the back of a winged white horse which is suckling its foal. Rather than alienated outsiders, these good companions exist in some benign world where tents are like theatrical drapes, where theatrical roles merge with the players and the world beyond is ancient and picturesque. It suggests a world where history is continuity rather than change.

War Fever

Cubism was attacked in wartime France as a German form of culture. Nationalist passions ran to fever pitch during the First World War. *Parade* had been greeted at its première by shouts of "Sales Boches!" (Dirty Germans). Many of Picasso's patrons were German. Kahnweiler, for instance, spent the war in Switzerland and his collection was sequestrated by the state. In nationalist rhetoric, Germany was associated with romantic disorder and individualism, whereas France was the inheritor of the classical tradition, the visual culture of the Renaissance and the universality of reason. Picasso, Apollinaire, Salmon and other avant-garde figures of the pre-war period re-configured their work and ideas in the context of an ideological battle around modern art, of which Cubism was the exemplar, and a return to tradition. Picasso figured on both sides.

Picasso's Neo-Classicism

Picasso had shown at Léonce Rosenberg's Cubist-dedicated Gallerie de l'Effort Moderne in 1919. However, Picasso did separate himself from the post-war Cubists. Three months after his exhibition with Léonce Rosenberg, he exhibited in the gallery of Léonce's brother Paul in which he showed early and some of his new and more conventionally representational work. Paul became Picasso's dealer and concentrated on exhibiting the neo-classical paintings which sold for higher prices than his Cubist output.

Picasso's neo-classicism had precedents in his pre-war work. For instance, the primitive classicism of Iberian sculpture was a source, as we have seen, for *Les Demoiselles d'Avignon*. Furthermore, the painting belongs to the classical or academic genre of history painting in which figures carry meaning beyond appearance, as gods or heroes whose histories speak allegorically of humankind. But Picasso's view of classical culture is understood through Nietzsche rather than J.J. Winckelmann (1717–68), the ideological father of late 18th-century neo-classicism, a view of classical culture which dominated the 19th century. In this view, Greek art was interpreted as having a "noble simplicity and a tranquil grandeur". It was, in Matthew Arnold's words, "sweetness and light".

Portrait of Igor Stravinsky

In his **Portrait of Igor Stravinsky** of 1920, Picasso has clearly taken
from Ingres and the tradition of drawing that took its linear simplicity
from classical sources. Picasso's line is not the subtle, soft pencil line
of Ingres' portrait drawings, but a hard line like those cut into the glaze
of a Greek pot. André Salmon in 1921 argued that Ingres was not a new
source for Picasso, for he had been a source for Cubism: "Ingres was a
great draughtsman, that is to say, a great deformer, that is to say a
great constructor." In his portrait drawings, Ingres suppresses the
seeming disproportion that comes from the literal transcription of, for
instance, the closeness of the sitter's hands and the distance of the
head from the eye of the artist. Picasso reverses this distortion, giving
Stravinsky a huge near thigh and hands and a small head. While more
Apollonian than **Les Demoiselles**, the drawing in its evocation of a
gross bodily presence and harsh line, seen next to that of Ingres still
suggests a Dionysian reading of the classical: not sweetness and light,
more the hard and the gross.

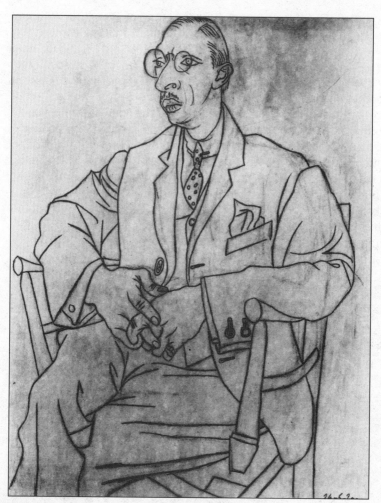

Two Nude Women

The gargantuan scale and simplification of form of *Two Nude Women Seated* of 1920 does show a debt to the painter Auguste Renoir (1841–1919) and the sculptor Aristide Maillol (1861–1944) and to Greek statuary such as the *Three Fates* from the Parthenon. Picasso may have seen this in the British Museum during the three months he spent in London working for the Ballets Russes on the designs for *Le Tricorne* in 1919. Like Maillol, Picasso gives the figures a simplified rotundity: all incidental features are absent in these idealized bodies. Picasso's Gargantuanism is more insistent than Renoir's. The spectator looks up at the painting over two metres high and at seated figures literally larger than life. Whereas Renoir's late large nudes are painted in warm light hues, these figures are modelled in browns and blacks. Renoir's late classicism was used to evoke an earthly paradise in which weight is dissolved by light. Picasso's figures are heavy with chiaroscuro and the right-hand figure resembles Dürer's figure of *Melancholia*.

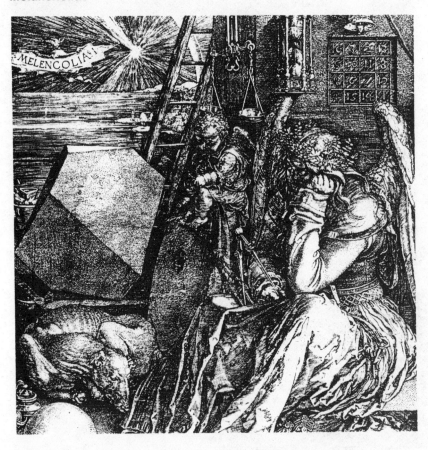

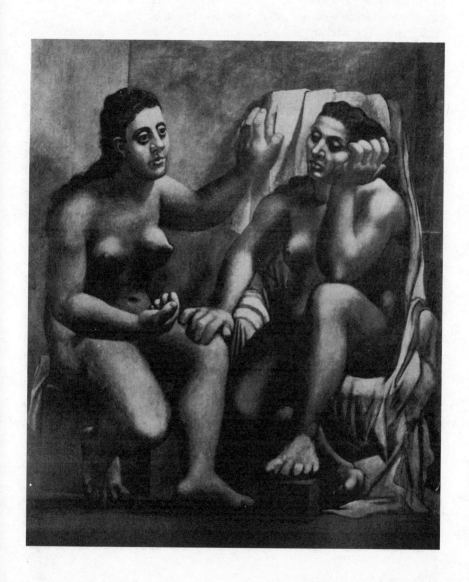

Early Synthetic Cubism in its imagery and means was unequivocally modern. It alluded to the street, the bar and the studio, in other words, to the everyday realities. It was an exception in Picasso's work. The fundamental feature of Picasso's classicism lies in his creation of archetypes. The work implies an iconography; it alludes to or suggests a mythology or a literature. Recurrent symbols and motifs from Western art are re-configured. From 1918 onwards, he usually spent his summers in the south of France, claiming that in this Mediterranean ambience mythological subjects came naturally for him.

Three Musicians

Three Musicians is Synthetic in method but has an iconography familiar in Picasso's pre-Cubist work, that of the *commedia dell'arte*. There are three masked figures at a table: a Pierrot on the left playing a

clarinet; a Harlequin at the centre playing a guitar; and a monk on the right singing from sheet music on his lap. They are in a shallow perspectival space. Like *Two Nude Women Seated*, the predominant colours are sombre brown and black.

Theodore Reff has interpreted the work as a lament for Picasso's first years in Paris. He identifies the Pierrot on the left as Apollinaire, who died in the post-war influenza epidemic. Max Jacob was converted to Christianity (Picasso was his godfather) in 1915 and in retreat as a Benedictine, and so he is the monk on the right. Picasso, as in *Family of Saltimbanques*, is the Harlequin in the centre. Just discernible sitting under the Pierrot is a dog, the silhouette of its Alsatian-like head to the right of the table. It may be Fricka, a dog Picasso owned in 1912. He was an inveterate dog owner.

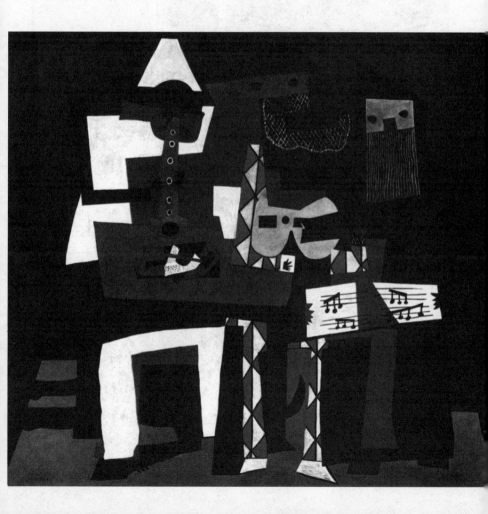

Encounter with Surrealism

We Claim Him as One of Ours

On 8 November 1918, Picasso first met the twenty-two-year-old poet André Breton in the corridor of the dying Apollinaire's apartment.

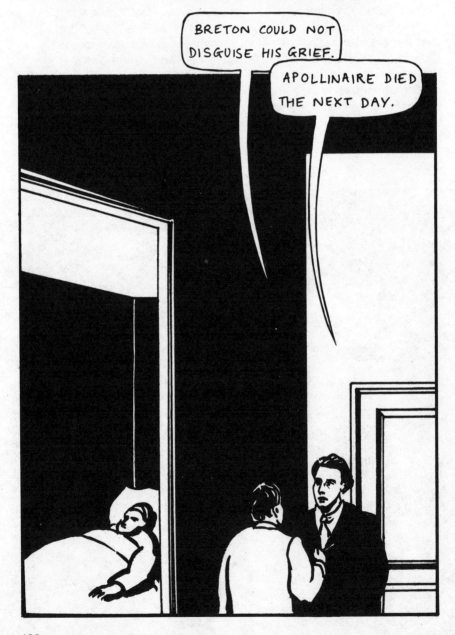

Surrealist Automatism

Picasso claimed his work was only influenced by Surrealism during 1933, and then limited mostly to drawings. By this, he probably meant the one time when he adopted an *automatist* technique in which the artist tries to suppress conscious control over his or her activity. André Breton (1896–1966) and Philippe Soupault had developed it as a way of writing poetry in 1919. It was claimed for automatism, in subsequent Surrealist theory, that it had a dream-like status.

The Unconscious Order

With the dormancy of consciousness during sleep, dreams give access to the unconscious. By suppressing reason in spontaneous creation, in the early days helped by drugs, the Surrealists argued that the order of the unconscious, an order suppressed by bourgeois culture, could speak.

For them, all that was real was rational, and all that was rational was real, therefore that which appeared irrational belonged to a future rationality. Art for Surrealism was a means to change the world.

Breton appropriated the term Surrealism, first coined by Apollinaire in his review of *Parade*, as the banner noun for a group of poets in the Surrealist Manifesto of 1924. Breton was carving out a distinct position for himself and his colleagues as an avant-garde which rejected the nihilism of Dada. Through various ideological wars and fractures, Surrealism continued as a group in the person of Breton and a shifting personnel of adherents up to 1939.

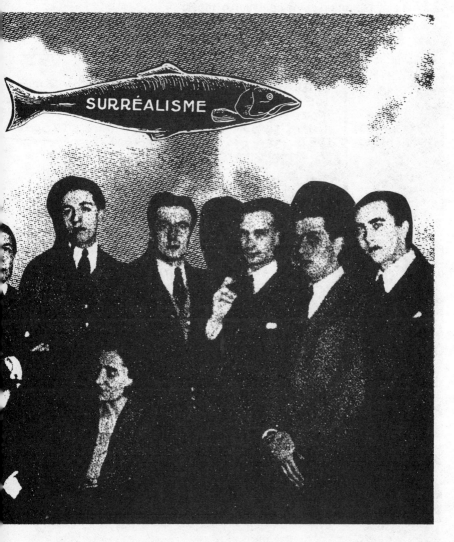

Picasso's Relation to Surrealism

Picasso's relationship to Surrealism is not straightforward. On the one hand, he had associations and friendships with some of the leading figures of Surrealism. He exhibited in Surrealist group shows. His work was reproduced in their publications. On the other hand, he did not sign any of their manifestos and statements or attend their meetings, and for the most part denied their impact on his work. He was, however, an ideological kinsman of Surrealism.

Like them, Picasso saw poetry as central to art, rather than the pictorial aestheticist aspiration to the condition of music.

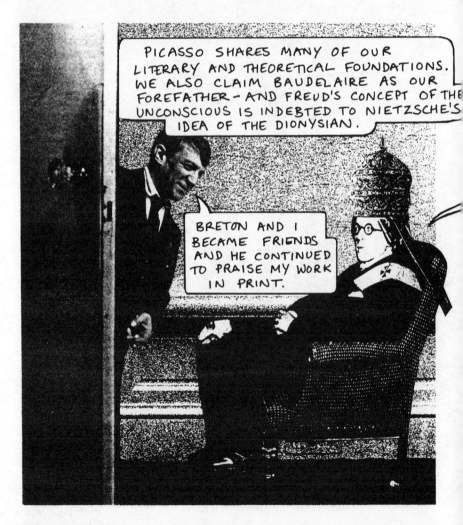

The British art historian Elizabeth Cowling has traced Picasso's public relationship to Breton and Surrealism in an article published in 1985. Her thesis is that Breton with deliberation plotted to incorporate Picasso and his reputation within Surrealism, lest his authority be claimed by another group. Picasso was listed by Breton as among those artists and poets leading to the future in an article in 1922.

Surrealism was also useful for Picasso. It served to detach him from the right-wing connotations of his neo-classicism, re-united him with the left avant-garde and the company of poets, and it kept him and his work part of current debate. Apollinaire was a model for Breton as a poet and writer. Picasso was a model too, but also for Surrealism as a whole. These young men honoured their selected fathers.

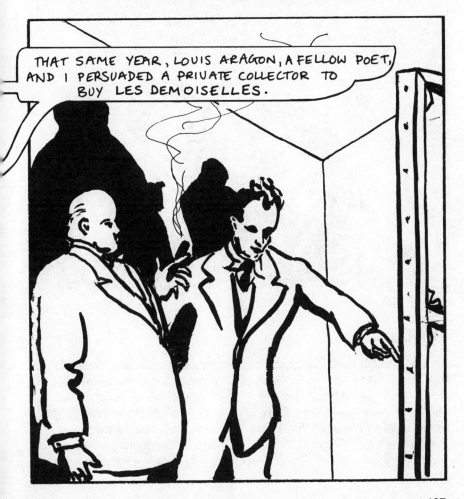

In July 1925, Breton became editor of the magazine *La Révolution Surréaliste*. It was the fourth issue of the magazine. He increased the number of reproductions of artists' work, the largest number, five, being Picasso's. In an article subsequently published as "Surrealism and Painting", he asserted the importance of the visual arts for Surrealism and of Picasso in particular. Indeed, he dismissed previous accounts of Cubism, arguing that it had led the way to Surrealism.

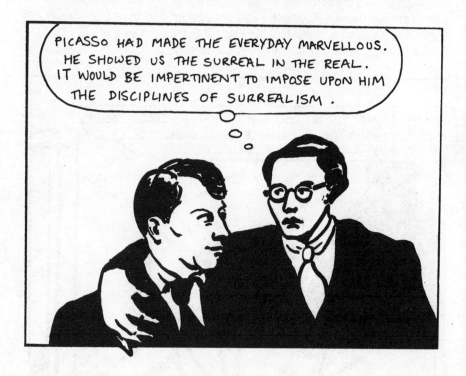

The Dance

Picasso was implicated in Breton's choice of works to be reproduced in this, previous and subsequent issues of the magazines, for they were mostly works still in his studio. Among the five works reproduced in that July issue of *La Révolution Surréaliste* was, for the first time, *Les Demoiselles d'Avignon* and a very recent painting, *The Dance* (sometimes called *Three Dancers*, and in this first appearance, *Young Girls Dancing Before a Window*) which he had begun in the spring of that year.

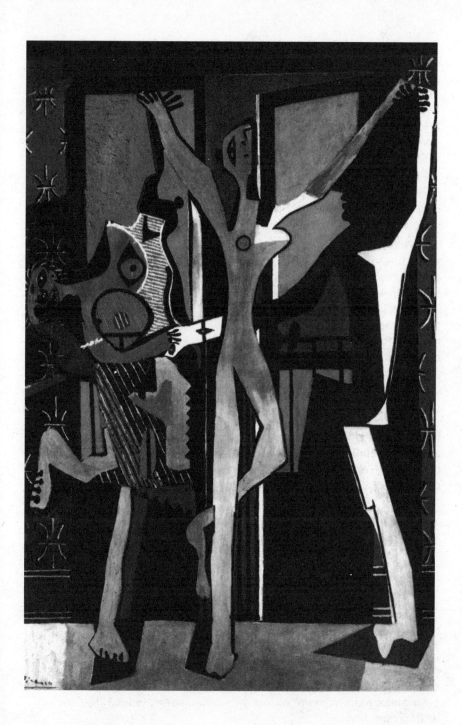

Penrose wrote of *The Dance*, "It is the first [painting] to show violent distortions which have no link with the classical serenity of the preceding years. It heralds a new freedom of expression." He thus implies that the neo-classical work lacked freedom and expression, two key values in the avant-garde rhetoric of Penrose's generation. "During the following years the human form was to be torn apart, not with the careful dissection practised during the years of analytical Cubism, but with a violence that has rarely been paralleled in the work of any artist." It is predominantly the female body which Picasso distorts and makes monstrous over the next seven years.

The painting is just over two metres high, at times the paint is very thick. The colour is heavy and opaque to cover what lies beneath it. The picture is made of contradictions: among the sickly luxuriance of the softer hues of browns, yellows, off-whites and pinks are an electric blue and a savage alizarin red. Non-perceptual signs are mixed with effects of light in which shadows become silhouettes, highlights contradict apparent light sources, and the sky turns from bright blue to a dark purple where the windows are open. It is in these and other devices that much of the violence of the picture resides, for two of the circle of dancers move without threat. On the left, the dancer steps high as if in some formal, stately dance. She is remote, unlike the other figures; we cannot see her eyes, she wears dark glasses. The central figure opens its arms high in what might be a balletic sign of joy. It is the third figure in which a physiognomy of rage appears: black-eyed, mouth open, teeth exposed, limbs in jagged, flaying motion, clothed but breasts, like an eye, as a hole, as a silhouette, exposed. But then, in the shadows between the arms of the right hand and central dancer, there is the profile of a face.

Picasso never liked the title given to *The Dance*. He told Penrose it should be called "The Death of Pichot".

It is his silhouette that can be seen in the upper right quarter of the painting. The Catalan painter Raymond Pichot had been married to the promiscuous Germaine who Casagemas had attempted to kill along with himself.

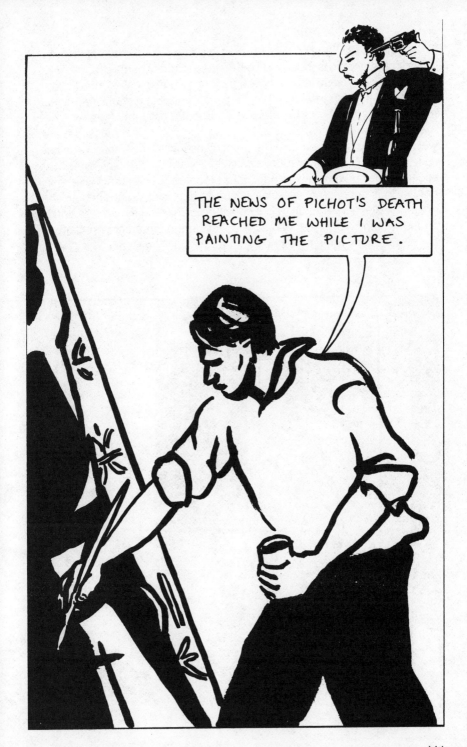

The marriage of Olga and Picasso was in painful crisis. The bitterness of their relationship is indicated by the one-sided accounts of Olga given by those whose knowledge of their relationship came from Picasso. John Richardson writes, "Picasso's adoption of this new style [neo-classicism] reflects the *embourgeoisement* brought about by marriage to a woman who, besides being silly and irredeemably square, was infatuated and jealous to the point of insanity. The reaction against a life of first nights, followed by nice little dinners, followed by hysterical scenes, was not long in coming. Just as Picasso's love for his wife parallels his adoption of neo-classicism, so did his subsequent hatred of her parallel his rejection of it. The failure of Picasso's marriage and demise of the backward-looking style that it engendered are proclaimed by the cacophony, the metaphoric contortions of **The Dance**.

Richardson writes with misleading venom. It would follow from his collapse of Picasso's work into the story of his personal life that his happiness with Olga lasted only as long as his neo-classicism, but that was six or seven years, rather than "not long". Certain women are the sources for Picasso's images of women, but those images are not necessarily expressions or symptomatic of his relationship with them. For instance, in the early 1930s Picasso depicts the secret mistress he had met in 1927, Marie-Thérèse Walter, as a monster on a beach, but he went on to depict her as luxuriant flesh and sensuality in interiors. Picasso may have deployed his thoughts and feelings about his dancer wife and Germaine Pichot, but the work is not simply autobiographical. Furthermore, as we have seen, *The Dance* is not a cacophony of contortions. It is formally more complex and emotionally more ambiguous than that.

In Picasso's paintings, women, even when based upon particular women, are for the most part paintings of "woman". In that sense, they are, as feminists have charged, images of women as nature, but their significance does not stop there. By characterizing nature, they characterize a conception of what is given in at least the male condition, and for Picasso, as has been said, male desire and its object was a given, it was the authentic engagement with life. Rather than seeing **The Dance** as three women, it can be read as three aspects of woman as seen in male desire: the elegant and aloof figure on the left, the welcoming naïveté and openness in the central dancer, and the vengeful furies on the right.

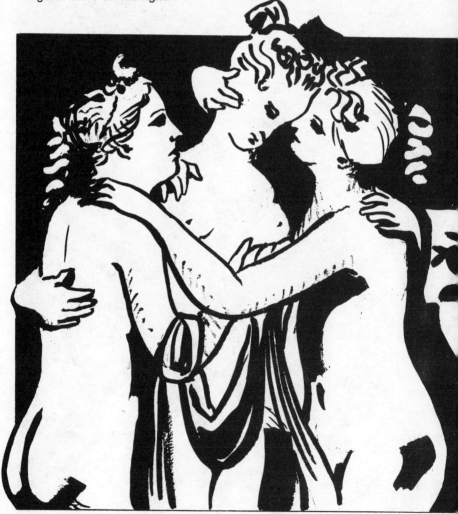

What has been rejected in *The Dance* is the unified vision of woman and, by implication, of nature and desire. Gone are the women heavy with stoic wisdom and virtue of the neo-classical paintings. It served to disassociate him from the neo-classical vision of a unifying order, the narcissistic myth of right-wing culture. It articulates the irreconcilability of desire and things as they are. While indebted for some of its imagery to the wide-ranging interest of the Surrealists in primitive art, it is not politically Surrealist. Surrealism was communistic and revolutionary, it assumed the possibility of a reconciliation of desire and social life, whereas Picasso's vision in *The Dance* is tragic in the sense that it suggests we are condemned to being not at home in the world.

Picasso kept possession of what he regarded as some of his most important works: *The Dance* remained in his collection until he was persuaded to sell it to the Tate Gallery by Roland Penrose in 1964.

For Clement Greenberg...

Picasso was taking what was already high art and larding it with redundant high art content. "Yet *The Dance* goes wrong, not just because it is literary, but because the theatrical placing and rendering of the head and arms of the centre figure cause the upper half to wobble." If conclusive unity is the overriding requirement, as it was for Greenberg, then this may well follow. If not, then this "wobble" can be seen as a device, rather than as a mistake.

Crucifixion

Roland Penrose offers this brief description: "Around the central figure of Christ nailed to the cross are two more distant crosses from which the thieves have been removed. Their mangled corpses lie in the bottom corner at the left. There are also in the foreground the two soldiers playing dice for the garments of Christ and the ladder at the top of which a small figure nails the right hand of Christ to the cross."

Before Christ on the cross is the figure which Penrose identifies as the Virgin Mary. The head is an open mouth with teeth, suggestive of a castrating vagina, a reoccuring image in Picasso's work at this time. A miniature picador thrusts a lance into the side of the Christ, and, looming over him, is a mantis-headed figure seeming to carry a rock like some Sisyphus. On the right, what we know from the preparatory drawings to be an ideogram for a woman bent over backwards; her arms in supplication are relocated to, and dominate, the upper right side of the painting.

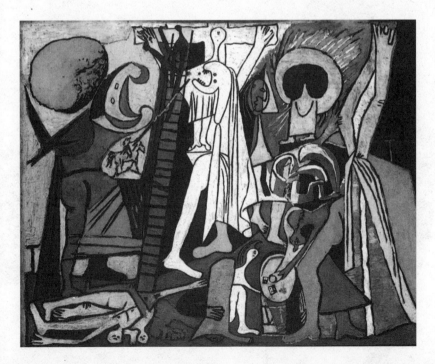

Le Cadavre Exquis

If formally *The Dance* is a synthetic Cubist painting, *Crucifixion* of 1930 is a Surrealist one. This is not because of its automatist method, on the contrary, it was preceded by many drawings, but because it has the formal characteristics of another Surrealist method, Le Cadavre Exquis. André Breton gave this definition in 1948 of the Surrealist use of a childhood game they started to play in 1925: "Exquisite Corpse: Game of folded paper played by several people, who compose a sentence or drawing without anyone seeing the preceding collaboration or collaborations."

In the graphic form of the game, participants continue the lines that emerge from the previous contribution hidden by a fold of the paper. What emerges tends to be an amalgam of images of violently changing scale and styles. What holds the images together is a continuous line, as in *Crucifixion*. Picasso further disrupts the image with irrational changes of colour, light yellows and greens with red and black.

Bataille

Ideologically, however, *Crucifixion* is not Surrealist. Its intellectual debt lies with a figure outside Breton's approved circle, Georges Bataille (1897–1962). While Bataille explored the uncivil motivations of human action, in particular the convergence between eroticism, cruelty and death, he rejected the Surrealist political vision. On being asked by Breton to join a group to reform the Surrealist alliance in 1930, he replied...

In the late 1920s and early 1930s, Bataille conducted his critiques of philosophy and arguments about art in attacks on the humanist and aestheticist readings of primitive art by contemporary ethnographers. Rather than giving form to humankind's image of itself, primitive art despoils the image of man:

ART PROCEEDS IN THIS WAY BY SUCCESSIVE DESTRUCTIONS. THUS INSOFAR AS IT LIBERATES INSTINCTS, THESE ARE SADISTIC.

Whereas philosophy and the systems of representation by which we understand the world set out boundaries and create form, art punctures the limits of these distinctions. Such a distinction is that between the sacred and profane, but Bataille does not proceed through linguistic distinctions, rather he aborts a term, punctures it. In *Crucifixion*, Picasso could be described as having aborted the most sacred image of Christian culture.

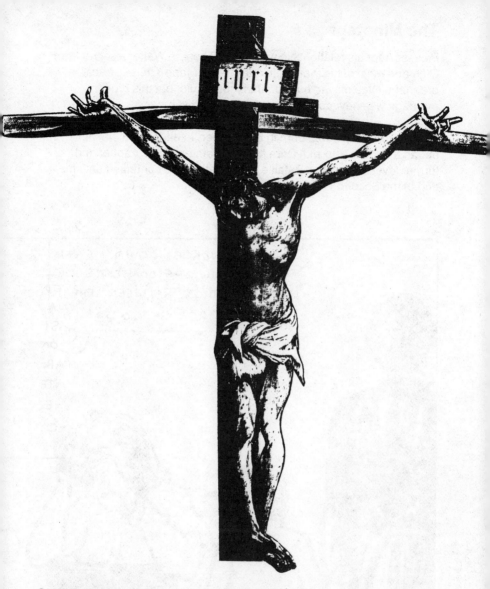

Crucifixion deploys the iconography of Bataille and Surrealism's wide-ranging research into "primitive art", Christian myth and imagery, and a vocabulary of bodily distortions that Picasso had developed in the last five years.

Penrose takes an argument about the painting from another historian, Ruth Kaufmann, who pointed out references to pagan and primitive religions to suggest "the primeval sacrifice of the god-king conducted here with 'human irrationality in the form of hysteria, brutality, and sadism'."

The Minotaur

Picasso kept his relationship with Marie-Thérèse Walter a secret from Olga and most of his friends. In early 1935, Marie-Thérèse became pregnant. Olga moved out with their son Paulo, but this broken marriage was never officially concluded by divorce.

His daughter Mayo was born in September. In early 1936, he met and began a relationship with Dora Maar, a painter, photographer and former lover of Georges Bataille. The relationship continued until the end of the Second World War.

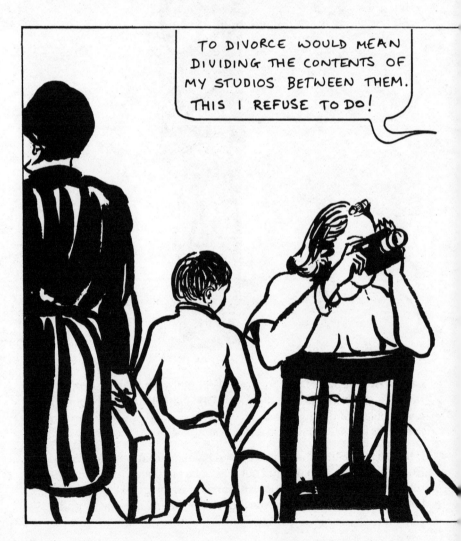

Up to the 1920s, short and thick-bodied Picasso personified himself periodically in his work as a youthful, slim, athletic and androgynous Harlequin. The last major appearance of a young Harlequin is in a portrait of his son Paulo in 1924. At the age of forty-three, Picasso passes on the persona of his youth. By the mid-1930s, a new persona was elaborated in prints and drawings: heavy, male and hirsute, ancient and brutal, the bull-headed Minotaur carries the weight of Picasso's sense of himself and of his art in middle age.

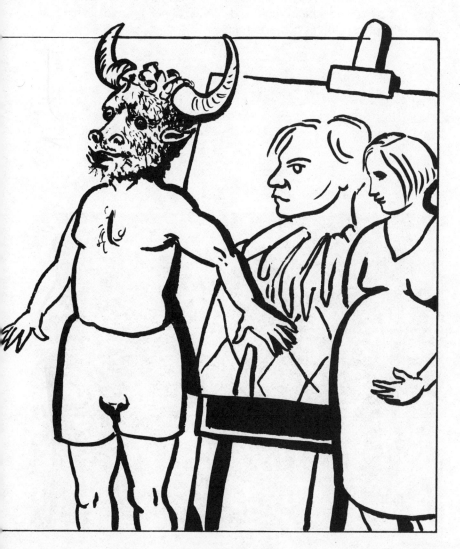

Minotauromachy is an etching made in the spring of 1935. It was printed in five versions of which this is the last. A storm is imminent. On the sea's horizon, the sail of a boat is arched by the wind, and a rain cloud in the near distance precipitates. Ashore, two women feed doves in a window and look down into a forecourt into which strides the Minotaur. He carries a dark sack, and before him prances a gored horse carrying a dead woman matador. A bearded man, mouth open, escapes up a rustic ladder, looking back to where a girl stands holding in one hand flowers and in the other a candle whose light illuminates the horse and the white exposed body of the matador. The Minotaur holds up his hand against the light and, staring at the girl, avoids the sight of the product of his own erotic violence.

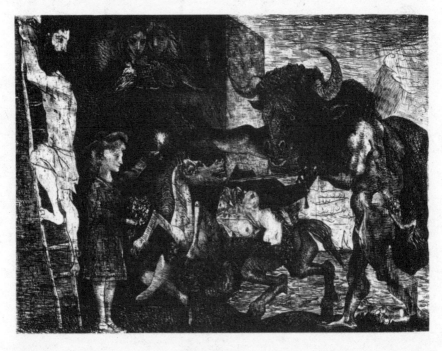

Bull Disembowelling a Horse

This reading is informed by the imagery of the largely graphic work that preceded it: for instance, **Bull Disembowelling a Horse** of 1934. In the 1920s, Picasso had returned to what had been a subject in his youth in Spain, bull-fighting. In the early 1930s, images of the bull goring a picador's horse watched by a girl spectator (in this ink drawing too she is holding a light) became a preoccupation. This rekindled interest may have been stimulated by Bataille.

In his pornographic novel **Story of the Eye**, published in 1928, the insatiable Simone is excited by bull-fighting and in particular by the horn of the bull plunging into the flank of a mare: "that ludicrous, raw-boned mare gallops across the arena, lashing out unseasonably and dragging a huge vile bundle of bowels between her thighs..."

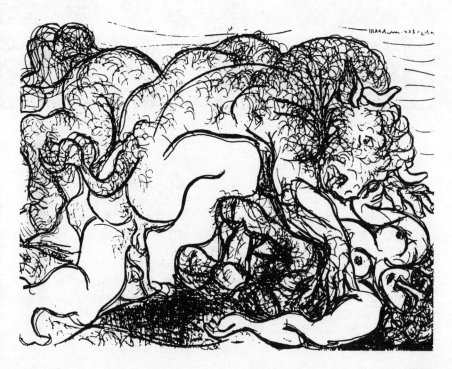

The Minotaur was born of hubris and bestiality. Minos, the King of Crete, failed to sacrifice a white bull promised to Neptune, who in revenge caused the King's wife to desire and couple with the bull. The monstrous offspring of this union was confined to a labrynth and fed upon flesh of boys and girls. For the Surrealists, the idea of a disorientating architecture below ground inhabited by a man-animal had echoes with their conceptions of the mind. The Minotaur had already appeared in Picasso's series of etchings inspired by, but far from illustrating, Ovid's *Metamorphoses*. In 1933, he was asked to make a cover for a magazine, *Minotaure*, named by Bataille and partly edited by Éluard and Breton, and to which the young psychiatrist Jacques Lacan contributed.

In the Ovid etchings, the Minotaur is a benign companion, a sociable
carouser, a lover and a sleeping giant gazed at by his female
companion. But, in a drawing of 1933, the Minotaur crushes down upon
the bodies of a horse and a woman in the act of rape. The suggested
crime of the Minotaur in *Minotaromarchy* is both sexual and violent.
The image can be read as a confrontation between two kinds of truth:
the innocent female truth, exposed by the little girl surrounded by the
attributes of home and husbandry, as against the authentic truth of
male sexuality that has emerged from the uncivil force of sea and
storm.

The Spanish Civil War

On 18 July 1936, the military commanders in Spanish Morocco began a revolt against the Popular Front Republican Government of Spain. Assisted by troops from Fascist Italy, air support from Nazi Germany and a policy of non-intervention from Britain and France, the insurgents, led by General Franco, overcame, after three years of civil war, the resistance of the government forces supported by aid from the USSR and volunteers from across Europe and the USA. Madrid surrendered on 28 March 1939. Three-quarters of a million people had been killed.

ESPAÑA
FUÉ, ES Y SERÁ
INMORTAL

The Spanish War raised the issue of Fascism versus Democracy to a different plane.

Anthony Blunt in his book, *Picasso's* **Guernica**, published in 1969.

IT BROUGHT THAT ISSUE TO WESTERN EUROPE. EVEN FOR THE MOST IVORY-TOWERED INTELLECTUAL, IT MEANT THAT THE TIME FOR NOT TAKING SIDES WAS PAST.

In the propaganda war, the right-wing Nationalists accused the Republican government forces of shooting priests, raping nuns, burning churches and destroying works of art. Part of the riposte was to offer the symbolic directorship of the Prado museum to the most internationally known Spanish artist: Picasso. He accepted.

Dream and Lie of Franco

In January 1937, Picasso made the first plate of **Dream and Lie of Franco**, a suite of two etchings divided into a series of nine images per plate. They depict Franco as a vainglorious, hairy little polyp on legs, and show the destruction his antics, on behalf of Church and Tradition, wreaked upon nature, culture, women and children.

Also in January, Picasso was asked to paint a mural for the Spanish Government Pavilion at the International Exhibition, which was to take place in Paris in June 1937. He agreed, found a room large enough to work in, but had not decided what form the mural would take.

Destruction of Guernica

On 27 April 1937, *The Times* of London correspondent wrote:
"Guernica, the most ancient town of the Basques and the centre of
their cultural traditions, was completely destroyed yesterday afternoon
by insurgent air raiders. The bombardment of the open town far behind
the lines occupied precisely three hours and a quarter, during which a
powerful fleet of aeroplanes did not cease unloading on the town
bombs and incendiary projectiles. The fighters, meanwhile, plunged
low from above the centre of the town to machine-gun those of the civil
population who had taken refuge in the fields. The whole of Guernica
was soon in flames..."

On 1 May, Picasso began the sketches for *Guernica*. By 11 May, the composition was outlined on a canvas over 7.6 metres long and 3.4 metres high. Between then and its completion three weeks later, it underwent various alterations. At seven stages in the process, it was photographed by Dora Maar. On 7 June, Picasso completed the second plate of *Dream and Lie of Franco*. The etchings were published with an accompanying poem by Picasso in aid of the Spanish Republic. On 12 July, *Guernica* went on display in the Spanish Pavilion.

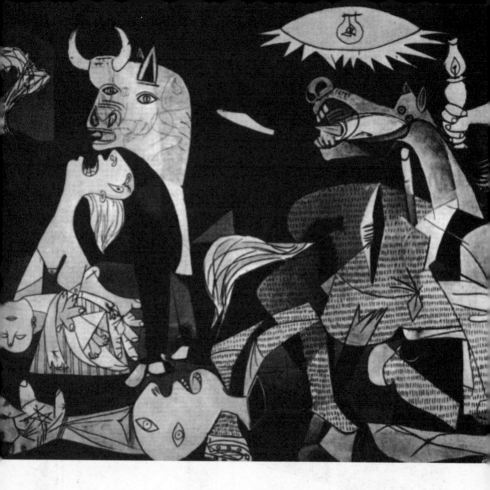

Guernica

Guernica is an unheard scream. With one exception, each mouth is
open, only the baby dead in its mother's arms lies lank and silent on the
left of the picture. "Cries of children cries of women cries of birds cries
of flowers cries of timbers and of stones cries of bricks cries of furniture
of beds of chairs of curtains of pots of cats and of papers..." This is
part of the poem Picasso wrote to accompany **Dream and Lie of
Franco**.

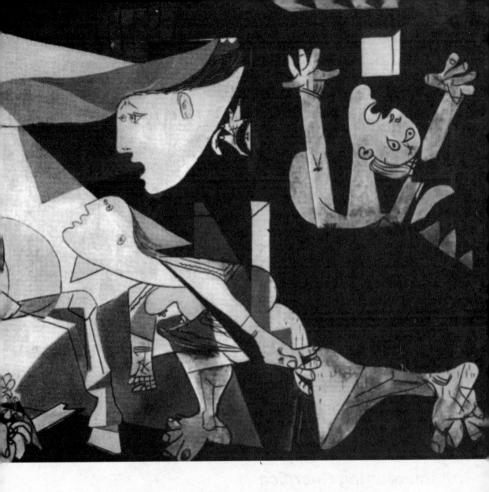

Guernica deploys motifs from many early works: for instance, the
upturned dead baby's face; on the right, the supplicant hands held aloft
of the women in the burning building; flames like teeth come from
Crucifixion, as do bodies lying in the bottom foreground, here a broken
statue of a soldier. As in ***Minotauromachy***, from a window a woman
looks down upon the scene, but now in horror, and it is her extended
arm that holds the revealing light which illuminates the injured horse in
the centre of the picture. The doves she had fed are now a single
screeching bird between the heads of the horse and bull. In the light of
Picasso's use of the bull/minotaur, this bull too is ambiguous: it carries
some connotation of Picasso himself, the one living male spectator of
the event. It is brutality personified, but it is also the bull of Spain that
defies Franco in ***Dream and Lie of Franco***.

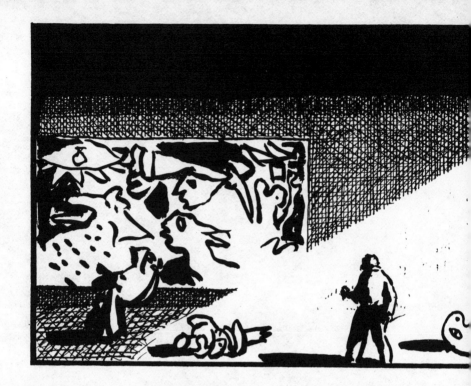

Interpreting *Guernica*

In this reading, Picasso does not exempt himself from implication in the violence, nor is the spectator given an unambiguous position. In the making of the picture, that position was removed. Among the many alterations the work underwent in the three weeks of its production, the most significant is in the transformation of the broken statue of a soldier. In the first version, he is a dying soldier rather than a statue. He raises one arm in a clenched-fisted Republican salute that dominates the centre of the canvas, the other arm lies in the foreground gripping a broken sword, and there it remained. In the second version, the raised arm is still aloft, the clenched fist is drawn more specifically and it holds ears of corn, and behind is a burning sun. In the final version, the soldier has become a broken statue, the once raised arm lies in the left bottom foreground, the hand is open in a gesture of pain. In the space it once occupied is the screaming horse's head, and the sun has become an electric light.

In other words, removed is the defiant, hopeful and specifically Republican gesture of the clenched fist holding the potential of new growth in the light of a nurturing sun. It is replaced by an anguished animal and sterile unnatural light. The picture's darkness becomes that of a closed room rather than infinite night.

In effect, the changes remove defiance, hope and distance from the picture. As in *Les Demoiselles*, the initial text suggested by the early version, which gave the viewer a shared remove from the picture, is gone: in the first, a narrative; in *Guernica*, a political stance. Only the title holds the work to the prophetic abomination that prompted it, and no clue within the picture signals the political allegiance of its author. Now there is nothing that holds out political hope, that suggests there is any redeeming potential in the event. What survives are women, the bull and a flower that grows by the broken sword of the soldier.

Criticisms of *Guernica*

The painting was much criticized by both politically left- and right-wing critics. In August 1937, writing thirty years before the publication of his laudatory book on *Guernica*, the young anti-fascist and communist fellow-traveller Anthony Blunt described the painting in The *Spectator* as "the expression of a personal brain-storm which gives no evidence that Picasso has realized the political significance of Guernica." Later that same year, he wrote . . .

PICASSO SHOULD HAVE SEEN MORE THAN THE MERE HORROR OF THE CIVIL WAR, HE SHOULD HAVE REALI ED THAT IT IS ONLY A TRAGIC PART IN A GREAT FORWARD MOVEMENT; HE SHOULD HAVE EXPRESSED THIS OPTIMISM IN A DIRECT WAY AND NOT WITH CIRCUMAMBULATION SO OBTUSE THAT THOSE OCCUPIED WITH MORE SERIOUS THINGS WILL NOT HAVE TIME AND ENERGY TO WORK OUT ITS IMPLICATIONS.

In 1938, *Guernica*, with over sixty studies, was toured around Britain under the auspices of the National Joint Committee for Spanish Relief. Thousands of people went to see it and it was the object of much press attention and argument.

The poet, art historian and critic Herbert Read (1893–1968) defended the work against Blunt's and similar strictures. "It has been said that this painting is obscure – that it cannot appeal to the soldier of the Republic, to the man in the street, to the communist in his cell; but actually its elements are clear and openly symbolical. The light of day and night reveals a scene of horror and destruction: the eviscerated horse, writhing bodies of men and women, betray the passage of the infuriated bull, who turns triumphantly in the background, tense with lust and stupid power; whilst from the window Truth, whose features are the tragic mask in all its classical purity, extends the lamp over the carnage."

Clearly the work is not as self-evident as Read argues: the bull's position does not support Read's narrative and it requires "symbolical" stretching to attribute the burning house and the spear through the horse to the passage of the bull.

Read called himself an anarchist in the 1930s, but his criticism is better described as liberal humanistic: art was on the side of universal good. The artist and writer Wyndham Lewis, a figure of the political right, saw *Guernica* in the USA where it and its accompanying works toured in 1939 and 1940. He argued that, as society was now falling apart, the politics of Picasso's work was irrelevant; as an enemy of existing civilization, he was being outdone by current events. Lewis saw *Guernica* as a failure, but for reasons of art. "It is a big, highly intellectual poster, uninteresting in colour, and having no relation to the political event that was supposed to have provoked it. The inalterable "intellectuality" – the frigidity, the dessication – of Picasso is demonstrated more forcibly by the largest of his canvasses than anything else could have done..."

Lewis is right in that *Guernica* is an intellectual poster and consequently colour has limited function, but the work does have a relation to what prompted it. By refusing to be reducible to the politics of the event, it articulates an uncomfortably ambivalent view of violence.

The Second World War

On 1 September 1939, Germany invaded Poland, and two days later France and Britain declared war on Germany. The Second World War had begun. *Guernica* was in the USA for Picasso, Forty Years of His Art, curated by Alfred Barr at the MOMA, New York. Picasso left *Guernica* and others of his works included in the exhibition with the Museum. Whereas the others were returned to him after the war, *Guernica* remained on extended loan,

Franco remained dictator until his death in 1975. In 1981, Picasso's legal adviser and heirs concluded that sufficient democracy had returned in Spain, and *Guernica* was sent to the Prado in Madrid and has since been rehoused in the Casón del Buon Retiro.

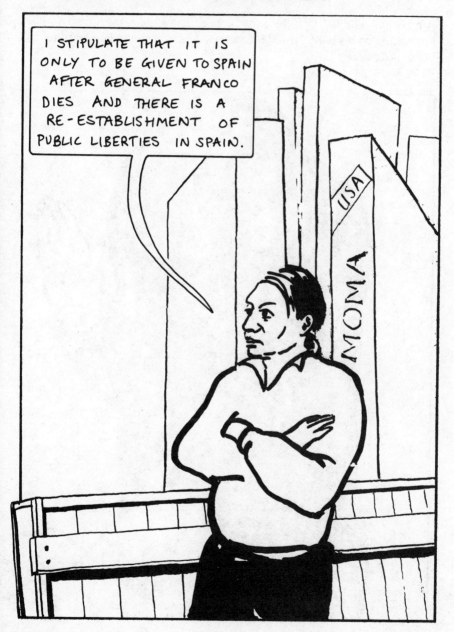

The Occupation

When the German army occupied France, many of the better-known Parisian artists left for America. Picasso remained. His world fame protected him. No action was taken when he was caught eating in black-market restaurants.

Arno Breker (1900–91), Hitler's favourite sculptor, claims to have intervened on his behalf when Picasso was caught smuggling currency out of the country.

In writing of Picasso's work during the war, there is a tradition of reading into the distortions of the figures anger at the horrors of Nazism, and into the relatively drab colours, greys, blacks and blued greens, intimations of the anxieties and material privations of the German Occupation of France. What does not appear is explicit images of cruelty and violence such as appears in the post-war period.

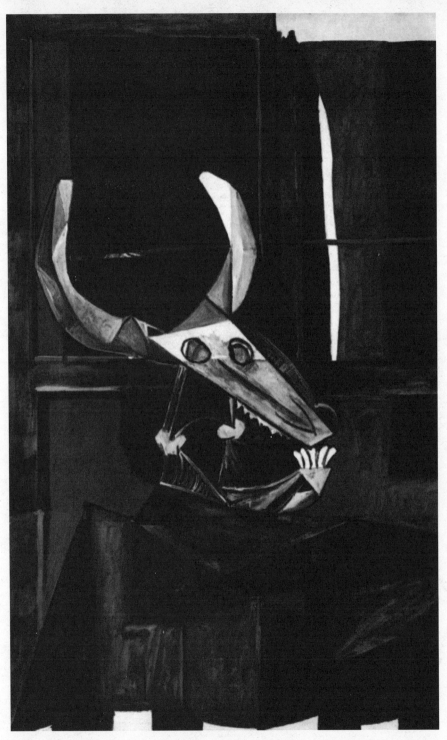

Still Life with Skull of a Bull

Still Life with Skull of a Bull was painted in Paris in April 1942. The skull is on a small table covered by a tablecloth painted in dirty green. The empty-eyed skull casts a black shadow on the closed window behind it. The window's glass, all but a slit of light, is blanked out from the outside, "painted the obligatory blue-mauve, against possible air raids," suggests the writer Pierre Daix. It is by recalling the bull and the Minotaur in Picasso's work of the 1930s that the skull takes on wider connotations.

The work can be seen as a shrine to Julio Gonzalez, the news of whose death reached Picasso as he made the painting, and, with Gonzalez, to the generation of avant-garde Spaniards destroyed in the Civil War or still dying in the current struggle. At that time, Nazism's defeat was far from assured. But the ugly skull records the death of Picasso's own persona of middle age, the great, powerful, lustful, destructive and creative bull/minotaur. Nietszche had said "in order to be creative one must first blast and destroy all accepted values"; but, as Wyndham Lewis had pointed out, blasting and destroying were now in much more able hands. Picasso mourns his own mythical self in the drab confines of a Parisian flat, shut off from the light and surrounded by the fears and anxieties of the Occupation.

Picasso continued his relationship with Dora Maar for much of the war. He continued to see Marie-Thérèse and his daughter and lived with them during the street fighting in Paris in 1944. However, in 1943, he had met the painter François Gilot (1921–). They became lovers and she was to be his companion over the next ten years. In 1944, Dora Maar became insane, possibly provoked by Picasso's treatment of her.

Max Jacob was arrested at the beginning of 1944. Cocteau launched a petition for his release. Picasso did not sign it. It was successful, but Jacob died of pneumonia before he could be released. He was in a transit camp on the way to Auschwitz.

Communist Picasso

In October 1944, Paris had been liberated, but there was still fighting in France. German surrender was still over half a year away. At the beginning of the month, it was announced that Picasso had joined the French Communist Party in *L'Humanité*, the paper of the PCF (Partie Communiste Français). Picasso was featured in the Salon de la Libération. As one of the few major artists to have stayed in France during the Occupation, he was a symbol of cultural resistance. He was also the symbol of modern art and art students and others demonstrated against his inclusion in the exhibition. A statement of support for him was published, signed by intellectuals of both right and left. At sixty-three, Picasso was still controversial.

How was it that Picasso joined a party allied and obedient to a regime which murdered more of its own people than Hitler destroyed in the Holocaust and which had vilified and destroyed avant-garde artists? The answer is that he didn't.

In Europe and the USA, the USSR was held in high esteem for its immense contribution to the War against Nazism. It had been essential to the Allied defeat of Hitler.

WHAT I JOINED AT THE END OF THE WAR WAS A PARTY WHICH HAD OPPOSED FRANCO, WHOSE MEMBERS HAD PLAYED A LEADING ROLE IN THE FRENCH RESISTANCE, AND WHICH PROMISED SOCIAL JUSTICE AND PEACE.

Many intellectuals in Western Europe joined. The Party, as Picasso knew it, was the Party of cultural intellectuals.

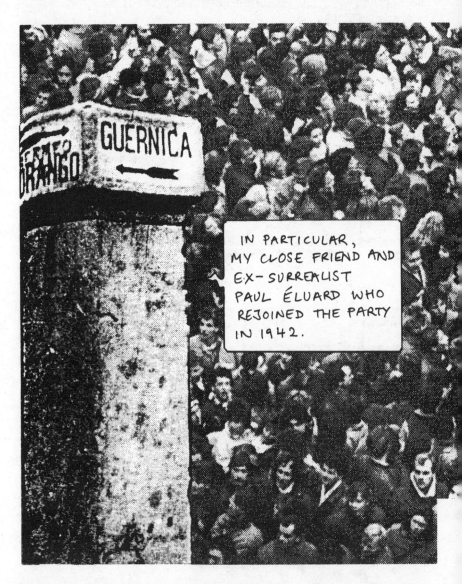

Marxism had become part of his cultural milieu and he would have been familiar with their arguments from the left critiques of *Guernica*. Just as he had encompassed aspects of the Call to Order and Surrealism within his work, so he took from communist aesthetics.

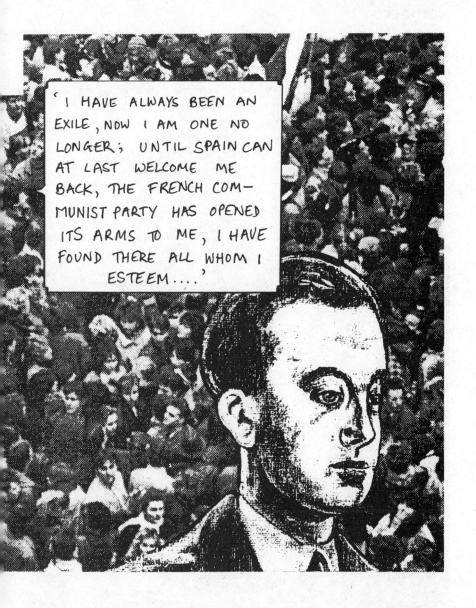

'I HAVE ALWAYS BEEN AN EXILE, NOW I AM ONE NO LONGER; UNTIL SPAIN CAN AT LAST WELCOME ME BACK, THE FRENCH COMMUNIST PARTY HAS OPENED ITS ARMS TO ME, I HAVE FOUND THERE ALL WHOM I ESTEEM....'

In an interview published in **New Masses** in New York and **L'Humanité** in Paris in late October, he said, "My joining the Communist Party is the logical outcome of my whole life...I have never considered painting as pleasure-giving art, a distraction; I have wanted, by drawing and by colour, since those are my weapons, to penetrate always further forward into the consciousness of the world and of men, so that this understanding may liberate us..."

Naródnost

Picasso's argument echoes a principle of Soviet Socialist Realism, that of *naródnost* (literally people-ness). This is the idea that art can express humane aspirations in a way that transcends ideology. There is in art something which speaks for the whole of humanity, which gives it a continuing life after the epoch in which it was produced has passsed. Such art in the present can escape the immediate demand that it serve and propagate the view of the working class and its most advanced agent, the Communist Party. These latter demands required an accessible art that showed the reality of the struggle between progressive and reactionary forces.

Picasso is claiming for his enterprise a progressive humanism, prompted by the desire to serve others. In this, he turned his back on Nietszche's conception of the artist as a self-creating I, an I unsubordinated to other Is.

As in the past, Picasso continued to work in a plurality of ways, each seeming to suggest different views of the world. But a humanist strand had begun in early 1943 with the drawings that were to lead to the statue **Man with Sheep** of 1944. In 1951, it was installed in the town square of the Communist municipality of Vallauris in the South of France, where he now lived for most of the year. Picasso had recently taken up making ceramics in the local potteries.

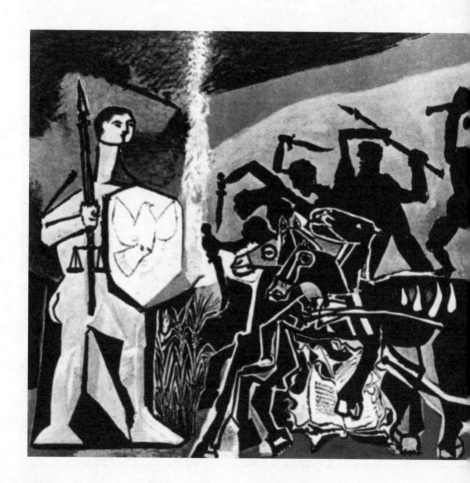

The War Mural

He was also given a deconsecrated chapel in the town to decorate as he thought fit. In 1952 he made two huge murals, **War** and **Peace**. They were installed in 1954, and the building became the "Temple of Peace".

The Korean War

The Marxist artist and writer Peter de Francia described the *War* panel in an essary of 1983. It "depicts an extraordinary funeral procession moving from right to left across almost the entire length of the wall. Against a background of massed greyish greens, a black hearse-like cart advances like some archaic war chariot... The procession lurches forward, the horses' hooves trampling over already burning books... about to be crushed by the forward wheels of the cart, a solitary pair of hands emerge from the darkness... Behind the horses, depicted as shadows thrown from figures engaged in some barbaric ritualistic war dance, a group of warriors brandishing archaic weapons charge forward in a kind of hysteria... Confronting this triumph of death, on the extreme left of the picture, stands the figure of a young man who, guardian-like, carries the scales of justice in his right hand. He is protected by a shield on which is inscribed the dove of peace." The demon-like figure in the cart with his bag of skulls is sowing hairy insects. "This", asserts de Francia, "is a direct reference to the American General Ridgeway and the repeated claims of the use of germ warfare by the Americans in Korea."

The work deploys allegory and rhetoric which de Francia argues are of use in the creation of ideological works. This argument helps to distinguish Picasso's humanist works. The rhetoric of the work lies in its attempt to persuade an audience, it plays upon emotions to express a message. It is a rhetoric of moral consensus. Some of his non-humanist works may be allegorical, but their symbolic meaning is ambiguous, any single reading has anomalies, is polyvalent and beyond good and evil.

Although it was preceded by many drawings, Picasso said that *War* and *Peace* was the most rapidly produced work of its size. "Painting is the sum of its destructions" suggests not just a general cultural point but also Picasso's method of painting in which he attacked by revision the relative banality of his first conceptions. *War* and *Peace* did not go through this process.

The Cold War Years

Picasso never gave up his membership of the PCF. To do so would have been interpreted as giving support to the other bloody side in the Cold War equation. His only public act of criticism was to sign a letter calling for a special congress of the Party to discuss issues raised by the Soviet invasion of Hungary in 1956. In the late 1940s and early 1950s he lent his presence to CP-backed events: he publicly supported the campaigns to stop the government executions of the Greek Communist Beloyannis and the Rosenbergs in the USA. He attended Peace Congresses in Warsaw, Rome and in Sheffield in the UK. He was invited to attend a congress in New York but was denied a visa by the US government. He twice received the Lenin Peace Prize – in 1952 and 1956.

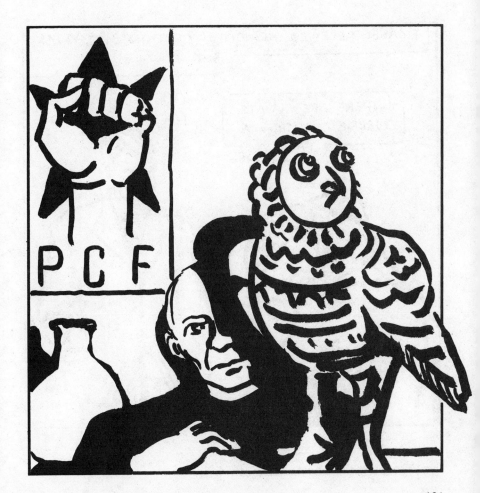

The Dove and Stalin

He made drawings and prints for CP-backed campaigns and events. In 1949, a lithograph of a pigeon or dove was used as a poster for a Peace Congress in Paris. This became the Dove of Peace which was used for anti-war posters many times. Versions of several of his drawings of doves were reproduced on postage stamps in China and other communist countries. On the death of Stalin in 1953, he did a portrait drawing for the cover of a communist literary magazine, depicting Stalin as a young man. The leadership and members of the Party took exception. The drawing and those who had published it were subject to public opprobrium. His work and its "formalism", its lack of "realism" continued to be the object of criticism within PCF and by official Soviet aestheticians.

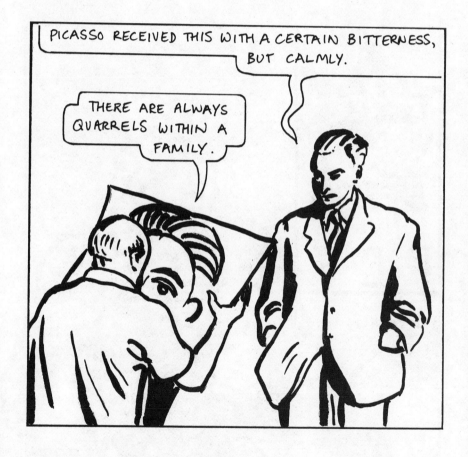

Ilya Ehrenburg, the Soviet writer.

Pierre Daix describes a conversation with Picasso in 1953, after the Stalin affair. "I found myself with a man whose patience and restraint had been exceeded. 'How', he asked, 'could these people prate about realism when they had never even begun to understand what goes on in a painting?' " "That's what reality is", Picasso went on to say, if Daix's memory is to be believed.

Here, Picasso appears to be giving up his humanist stance, in the sense of seeing his work as serving a cause, and reverting to the Nietzschean role of artist as self-creating, exemplifying the will to power.

Works of Old Age

Baudelaire said of the artist Eugène Delacroix (1798–1863) that in his old age he increasingly kept the company of past artists. Picasso after 1945 made versions of works by Velázquez and Poussin among others.

At seventy-two, Picasso turned to Delacroix's **Women of Algiers** as the starting point for a series of fifteen paintings.

Women of Algiers

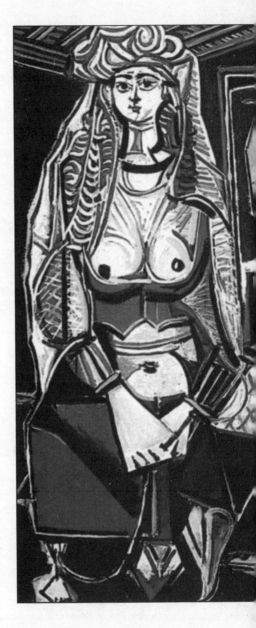

Women of Algiers, after Delacroix (final version) was completed at the beginning of 1955.

The figure on the left of ***Women of Algiers*** is Jacqueline Roche, with whom Picasso was to spend the rest of his life. François Gilot, having

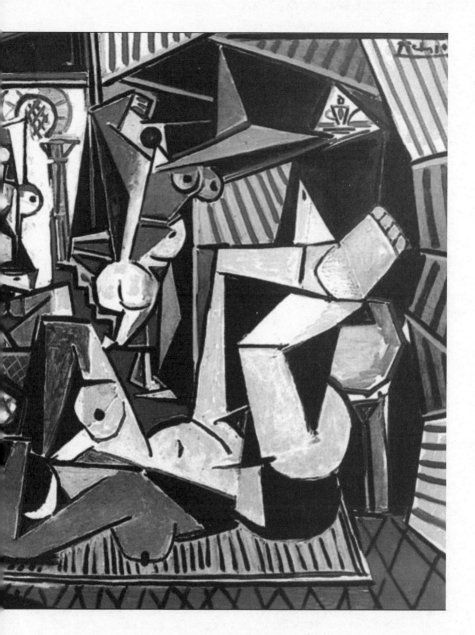

born him two children, Claude and Paloma, finally separated from him in 1953 and left to live and work in Paris. He now lived in the south of France. She published in 1964, in spite of Picasso's attempts to stop her, *My Life with Picasso*. For this, he broke off relations with his two children by her.

Criticisms of *Women of Algiers*

For John Berger, in **Success and Failure of Picasso** (1965), this reworking of past art was the mark of Picasso's failure. Picasso merely reconstructs the paintings formally. "But in terms of content the original painting is even less than a starting point. Picasso empties it of its own content, and then is unable to find any of his own ... If there is any fury or passion implied at all, it is that of the artist condemned to paint with nothing to say." But the painting does have things to say about painting. It takes up the erotic luxuriance of Mattisse's odalisques. Matisse had died in 1954.

Leo Steinberg, in his essay "The Algerian Women and Picasso at Large", 1972, argues that the painting takes on a major concern of Picasso's work: how to make, by the re-arrangement of human features, something more complex and intense than physiological sight and its conventions of representation. He traces the many variations made on the sleeping naked women that dominates the right foreground of the painting and how it is constituted of different views and postures of a body. "The quest embodied above all in the Sleeper is for the form that satisfies both the impulse of erotic possession and, at the same time, the most systematic investigation of the plane surface as a receptacle of information. In other words, to discover the unique coincidence which is at once diagram and embrace."

The picture is built upon a symmetry of cancellation: on the right hand, the Sleeper, a complex of many aspects, within a Cubist flatness animated by the servant holding a coffee pot; on the left hand, the single frontal aspect of the Smoker whose context has an inconsistent perspective depth given by the roof beams and the door jamb within which is a fourth figure diminished in scale by her distance. "A concord of contradictions; it is the principle of reciprocal countercharge – now expanded to a symphonic scale," writes Steinberg. A concord also held together, it should be added, by uniform reds, yellows and blacks with variations in blue.

At the End...

In the autumn of 1965, Picasso became ill with an ulcer. On what was to be his last visit, he went to Paris for an operation. On his return to the south of France, his convalescence was lengthy and he was from then on sexually impotent. By the spring of 1966, he began to draw and then to paint again. In August, assisted by the master engravers Aldo and Piero Crommelynck, he resumed printmaking, which was to continue with great abundance until the end of his life.

Etching, 8 September 1968

In these prints Picasso raided the past – his own and that of painting. They are witty, erotic and cruel. He mocked his own age and decreptitude. *Etching, 8 September 1968* (II) is part of a series that has as its central character the artist Raphael (1483–1520).

There is an Ingres painting of 1844, *Raphael and la Fornarina*, which shows Raphael, who was a famously amorous man, with his model on his knee glancing at his own painting of her. In Picasso's etchings, Raphael is making love to his model, palette and paint brush in hand, watched by some elderly voyeur. Sometimes the voyeur is a pope and sometimes artists, Dégas, Rembrandt and Michelangelo.

In this version Michelangelo has become an old snarling dog under the bed and it is a younger figure, that of Aldo Crommelynck, who pulls back the curtain like a doctor in the first drawings for *Les Demoiselles*. It is an old motif replayed.

Nude Man and Woman

In August 1971, nine months before he died, Picasso painted **Nude Man and Woman**. It is painted with the looseness but not the aggression and flamboyance that characterizes his late work. An old man seems to be struggling to rise: his body naked and pink, mouth open, right hand clenched, penis limp, one bony leg crossed beneath him, the other knee up. Behind him a woman sits, he could be on her lap, she seems to be holding, helping him. The sky is blue, he wears a yellow straw hat. He is unshaven, his cheeks are sunken and his great black eyes stare out at the viewer, helpless and ludicrous. A will, a mind trapped in its bodily infirmity.

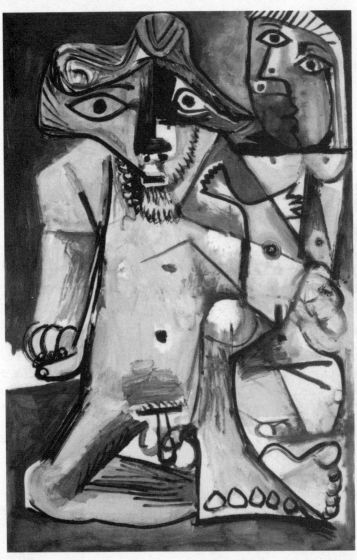

Picasso lived in modern culture, a culture discontented and stripped of metaphysics, of faith in some benign order of things. He rejected religious belief and could not sustain secular hope. His periods of identification with society evaporated. He returned to one central metaphysical belief, in art as self-creation. This has its own rigour, the denial of sentimentality and the comfort of the familiar. Constant self-creation requires constant self-abnegation. It is always the sum of its destruction or it is mere self-deception. In **Nude Man and Woman** he deployed that combination of aspects, that imagery between diagram and embrace to evoke the humiliations and terror of his own old age and impending death. Those staring eyes did not blink.

List of Illustrations

Further Reading

Arts Council of Great Britain, *Picasso's Picassos*, introduction by Timothy Hilton, London, 1981.

Ashton, Dore, editor, *Picasso on Art: A Selection of Views*, New York, Viking, 1972.

Berger, John, *The Success and Failure of Picasso*, Harmsworth, Penguin Books, 1965.

Blunt, Anthony, *Picasso's* Guernica, Oxford University Press, 1969.

Cowling, Elizabeth, " 'Proudly we claim him as one of us': Breton, Picasso, and the Surrealist Movement", *Art History*, Volume 8, Number 1, March 1985.

Daix, Pierre, *Picasso: Life and Art*, translated by Olivia Emmet, New York, Icon Editions, 1987.

Duncan, Carol, "Virility and Domination in Early Twentieth Century Vanguard Painting", in *Feminism and Art History: Questioning the Litany*, editors, Norma Broude and Mary D. Garrard, New York, Icon Editions, 1982.

Francia, Peter de, "Marxist Criticism and Painting", in *Marx – A Hundred Years On*, editor, Betty Mathews, London, Lawrence and Wishart, 1983.

Gilot, Françoise and Carlton Lake, *Life with Picasso*, New York, McGraw Hill, 1964.

Golding, John, *Cubism: A History and an Analysis, 1907–1914*, London, Faber, 1959.

Green, Christopher, *Cubism and its Enemies: Modern Movements and Reaction in French Art, 1916–1928*, London and New Haven, Yale University Press, 1987.

Greenberg, Clement, *Art and Culture*, Boston, Beacon Press, 1961.

Harrison, Charles and Paul Wood, *Art in Theory, 1900–1990: An Anthology of Changing Ideas*, Oxford, UK, and Cambridge, USA, Blackwell, 1992.

Heidegger, Martin, *Nietzsche: Volume I: The Will to Power as Art*, translated by David Farrell Krell, San Francisco, Harper, 1984.

Krauss, Rosalind E., "In the Name of Picasso" and "No More Play", in *The Originality of the Avant-Garde and Other Modernist Myths*, Cambridge, USA, and London, MIT Press, 1986.

Leja, Michael, " 'Le vieux marcheur' and 'Les deux risques': Picasso, prostitution, venereal disease, and maternity, 1899–1907", *Art History*, Volume 8, Number 1, March 1985.

Lomas, David, "A Canon of Deformity: *Les Demoiselles d'Avignon* and Physical Anthropology", *Art History*, Volume 16, Number 3, September 1993.

McCully, Marilyn, editor, *A Picasso Anthology: Documents, Criticism, Reminiscences*, London, ACGB and Thames and Hudson, 1981.

—— "Magic and illusion in the Saltimbanques of Picasso and Apollinaire", *Art History*, Volume 3, Number 4, December 1980.

Museum of Modern Art, New York, *Pablo Picasso: A Retrospective*, New York, 1980.

Penrose, Roland, *Picasso: His Life and Work*, Harmsworth, Pelican Books, 1971.

Penrose, Roland and John Golding, editors, *Picasso in Retrospect*, New York, Praeger Publishers, 1973.

Raphael, Max, *Proudhon, Marx, Picasso*, translated by Inge Marcus, edited and introduction by John Tagg, London, Lawrence and Wishart, 1979.

Raymond, Marcel, *From Baudelaire to Surrealism*, New York, Wittenborn, Schultz, 1950.

Reff, Theodore, "Themes of Love and Death in Picasso's Early Work", in *Picasso in Retrospect*, editors, Roland Penrose and John Golding, New York, Praeger Publishers, 1973.

Richardson, John, *A Life of Picasso: Volume I: 1881–1906*, London, Jonathan Cape, 1991.

Rosenblum, Robert, "Picasso and the Typography of Cubism", in *Picasso in Retrospect*, editors, Roland Penrose and John Golding, New York, Praeger Publishers, 1973.

Royal Academy of Arts, *Je Suis le Cahier: The Sketchbooks of Picasso*, London, 1986.

Steinberg, Leo, "The Algerian Women and Picasso at Large", in *Other Criteria: Confrontations with Twentieth-Century Art*, Oxford University Press, 1972.

—— "The Philosophical Brothel I and II", *Art News*, Volume 71, Parts 5 and 6, 1972.

Tate Gallery, *Late Picasso: Paintings, Sculptures, Drawings, Prints 1953–1972*, London, 1988.

—— *On Classical Ground: Picasso, Léger and the New Classicism 1910–1930*, Elizabeth Cowling and Jennifer Mundy, London, 1990.

—— *Picasso: Sculpture/Painting*, Elizabeth Cowling and John Golding, London, 1994.

Andrew Brighton is a critic and occasional curator. He has published articles in *Art in America*, *New Art Examiner*, *London Review of Books*, *Art Monthly* and other publications in the UK and abroad. He curated Blasphemies, Ecstasies and Cries at the Serpentine Gallery, London, in 1989. He is currently Head of Adult Visitor Programmes at the Tate Gallery.

Andrzej Klimowski is an award-winning designer and illustrator and the author-artist of the acclaimed graphic novel *The Depository*. He is also a lecturer at the Royal College of Art, London.